ZENGA
Brushstrokes of Enlightenment

# ZENGA
## Brushstrokes of Enlightenment

Catalog Selections, Entries and Essay
by
JOHN STEVENS

Catalog Essay and Organization
by
ALICE RAE YELEN

NEW ORLEANS MUSEUM OF ART

1990

Cover Illustration
HAKUIN Ekaku, *Blind Men On a Log Bridge*

Back Cover Calligraphy by John Stevens

4000 copies of the catalog were published for the exhibition
*Zenga: Brushstrokes of Enlightenment*

Exhibition Schedule

New Orleans Museum of Art       July 15-August 20, 1989
Mint Museum of Art              April 1-May 27, 1990
Seattle Art Museum             October 4, 1990-January 13, 1991
Los Angeles County             March 26-May 26, 1991
   Museum of Art

ISBN  0-89494-032-5
Library of Congress Catalog Card Number:  90-53276

Designed by Thomasgraphics, Baton Rouge, Louisiana
Produced and Typeset by Skip Brown, New Orleans, Louisiana
Photographs by Owen Murphy, New Orleans, Louisiana, except where
   otherwise credited
Printed by Dai Nippon Printing Company, Ltd.

# CONTENTS

# FOREWORD AND ACKNOWLEDGEMENTS

E. John Bullard, Director

For nearly twenty years, the New Orleans Museum of Art has been increasingly interested in the art created in Japan during the Edo Period from 1615 to 1868. This interest was initiated by a trustee, Dr. Kurt A. Gitter, for many years one of the major American collectors of Edo painting. With his generous support and encouragement, the Museum has built a large and varied collection that surveys all of the diverse styles that flourished during the Edo Period, including Zenga—painting and calligraphy by Zen monks. *Zenga: Brushstrokes of Enlightenment* is the latest in a series of exhibitions of Edo painting organized by the Museum.

Several earlier exhibitions, including the first in 1976, *Zenga and Nanga: Paintings by Japanese Monks and Scholars,* drawn from the Gitter collection, were curated by Professor Stephen Addiss of the University of Kansas, who served for several years as our Adjunct Curator of Japanese Art. Through research, publications and exhibitions, Professor Addiss has greatly expanded the knowledge and appreciation of Zenga in the West and has even focused attention in Japan on many previously overlooked or undervalued artists. His work on Zenga culminated in 1989 with the publication of the definitive study, *The Art of Zen: Painting and Calligraphy by Japanese Monks 1600-1925,* which accompanied an exhibition he organized with loans from American, European and Japanese collections.

The current exhibition, *Zenga: Brushstrokes of Enlightenment*, was in part inspired by Stephen Addiss' book and exhibition. Due to scheduling conflicts, we were unable to present *The Art of Zen* in New Orleans. With a sudden opening in our schedule in the summer of 1989, we decided to organize our own exhibition of Zenga drawn from collections just in New Orleans, including the Museum's. As the exhibition developed and we realized the quality and depth of material available locally, we were fortunate to engage as our guest curator John Stevens, Professor of Buddhist Studies at Tohoku Social Welfare University in Sendai, Japan. Professor Stevens, an American who has lived in Japan for many years, is an ordained Zen priest. Working closely with Alice Rae Yelen, Assistant to the Director for Special Projects, Professor Stevens approached the organization of the exhibition from a fresh perspective, utilizing his extensive knowledge and practice of Zen. Rather than presenting the exhibition in a traditional art historical manner, arranging works chronologically or by schools, Professor Stevens divided the works thematically, to inform the viewer about Zen theology and iconography.

Although Zenga has always been appreciated in Japan for its religious content, it has not received appropriate recognition from

collectors and art museums until recently. For the Japanese who value great craftsmanship and aesthetic refinement, the bold, often roughly brushed works by artistically untrained Zen monks can appear amateurish or naïve. During the past thirty years, it has been art collectors, scholars and curators in the United States, such as Stephen Addiss, Kurt Gitter, Peter Drucker and John Powers who have recognized the unique aesthetic qualities of Zenga. The great success of abstract art in the West also has contributed to an appreciation of Zenga, separate from its original theological function. That Westerners, who can not read Japanese and have no knowledge of Buddhism, are moved by Zenga attests to the universality of art.

We are most grateful for Professor John Stevens' enthusiastic participation and his willingness to devote a much greater amount of time to the project than originally planned. He not only devised the exhibition concept, he also wrote all of the individual catalog entries and the insightful essay, "The Spiritual in Zen Art." As an American-born Zen priest living in Japan and teaching Buddhist theology to the Japanese, Professor Stevens has made a unique guest curator.

Alice Rae Yelen ably coordinated the organization of the exhibition and the production of the catalog, as well as wrote the essay "Looking at Zen Art," based on her experience as an art historian and museum educator. Other members of the New Orleans Museum of Art staff made special contributions to this exhibition. Darrell Lee Brown, Assistant to the Curators, worked in all areas of the organization, particularly in typesetting and formatting the catalog. Daniel Piersol, Curator of Exhibitions, and Paul Tarver, Registrar, provided essential services in preparing the exhibition to travel. Curatorial secretary Joyce Armstrong prepared the manuscript, while volunteers Oscar Frishoff and Virginia Dupuy assisted in proofing. Ms. Yelen gratefully acknowledges the hospitality of Daizaburō Tanaka, who guided her to Hakuin's hometown and temples in Japan, as well as Professor John Stevens, Dr. Frederick Baekland and Dr. Roger Green who aided in editing her essay from different points of view.

Finally I wish to recognize the participation of the three American museums hosting *Zenga; Brushstrokes of Enlightenment.* I thank our colleagues at these institutions who assisted in circulating the exhibition, particularly Charles L. Mo, Mint Museum of Art, Charlotte, North Carolina; William J. Rathbun, Seattle Art Museum; and Robert Singer, Los Angeles County Museum of Art. The support of these three museums made possible the exhibition tour and the publication of the catalog, thereby allowing New Orleans to share its public and private collections of Zenga with other American cities.

# THE SPIRITUAL DIMENSIONS OF ZEN ART

by John Stevens

The Zen tradition traces its origin back to the enlightenment experience of Gotama, the historical Buddha who was born over 2,500 years ago in India. After first living as a prince and then as a religious seeker, one day Gotama sat resolutely in the meditation posture beneath a large tree, vowing to be enlightened or die. Following a night of the most intense contemplation, the inner and outer workings of the universe suddenly became clear to Gotama and he attained enlightenment. Gotama was thereafter called the "Buddha," one who is perfectly awake.

Zen represents the contemplative tradition of Buddhism. Meditation masters carried the Zen tradition from India to China and then it was transmitted to Korea, Japan, and, in the twentieth century, to the West. In Japan, painting and calligraphy became a primary teaching vehicle of the Zen masters from the sixteenth century onward, and Zen art is now recognized as being one of the glories of world culture. Devotees of Zen art, both in Japan and in the West, have uncovered and lovingly restored hundreds of magnificent pieces during the past fifty years; indeed, this exhibition largely consists of such newly discovered treasures. Significantly, these pieces—some unseen for centuries but still bearing a message as fresh and forceful as when first delivered—are appearing just when it is possible, for the first time, to display them throughout the world in exhibitions and by means of modern print technology.

Although permeated with humor, joy, and unrestrained freedom, Zen painting and calligraphy is comprised of far more than light-hearted cartoons, witty sayings, and delightful abstract images. True Zen art always imparts a deep message, a message as profound and universal as that revealed in the most venerable religious text or the most challenging philosophical treatise. It is a misconception to think of Zen art as a pleasant diversion from more "serious" forms of religious and artistic expression, on the contrary, a single Zen brushstroke by an enlightened master can reveal a new reality to the viewer.

## PAINTINGS OF THE MIND:
## THE DEVELOPMENT OF ZEN ART IN CHINA

The origin of ink painting in China is lost in antiquity but by the eighth century there was a definite shift from the formal, linear style of brushwork that characterized early Chinese painting to a more expressive, natural calligraphic style. Detailed, well proportioned and brightly colored painting gradually gave way to impressionistic "paintings of the mind," monochromatic representations of the essence, rather than the form, of things.

One reason for this change was the influence of Ch'an (Zen) ideals. Classical Buddhist art, the dominant force in Chinese art from the third to seventh centuries, was highly structured and strictly dictated. An image was thought to lose its spiritual efficacy if it deviated in the slightest from the iconographically correct form. Preliminary sketches, for example, were carefully constructed with compass and ruler. Such art reflected the canons of Buddhist scholasticism, tremendously complex and minutely detailed. Bodhidharma, the legendary Indian monk who personified Ch'an philosophy, came to China in the sixth century, it is said, in order to overturn the elaborate superstructure of doctrinal Buddhism. Bodhidharma symbolizes the rejection of all externals, and the demand for direct and immediate realization of the Buddha-mind in the here and now. Combined with the ancient Taoist principles of spontaneity, harmony and non-action, Ch'an teachings inspired Chinese artists to break free of confining rules, allowing them to portray the heart of things dynamically with a few vital strokes.

Perhaps the earliest reference to Zen, as opposed to regular brush-work, occurs in the *Platform Sutra of the Sixth Patriarch*, a text which relates the life and teaching of the illustrious Chinese master Hui-neng (638-713). Buddhist scenes, composed in accordance to canonical dictates, were to be painted on the walls of the monastery in which Hui-neng was laboring as a lay monk. Before the paintings could be executed, the abbot's top disciple Shen-hsiu sneaked into the hall one night and expressed his understanding of Zen by brushing this verse on the white wall:

> *The body is the tree of enlightenment,*
> *And the mind, a bright standing mirror;*
> *Keep it polished continually,*
> *And never let dust collect there.*

After viewing the calligraphy the next morning, the abbot dismissed the commissioned artist with these words: *"I have decided not to have the walls painted after all."* As the *Diamond Sutra* states, *"All images are unreal and false."* Evidently fearing that his disciples would adhere too closely to the realistic pictures, the abbot thought a stark verse set against a white wall better suited to awaken the mind. When Hui-neng heard the content of Shen-hsiu's verse, however, he thought it too rigid and orthodox. The poor lay brother had never learned to read or write, but Hui-neng's intuitive understanding of Zen was profound; he asked one of the monks to inscribe this poem next to Shen-hsiu's verses:

> *Enlightenment is not like a tree,*
> *Nor is there a mirror standing*
> *        anywhere;*
> *Originally not one thing exists,*
> *So where can dust alight?*

Upon seeing Hui-neng's "enlightenment poem," the abbot deter-

mined that he, and not Shen-hsiu, truly understood Zen. (Even today, Hui-neng's poem, especially the third line, is a favorite theme of Zen artists.)

Thereafter, art was used by Chinese and Japanese masters to reveal the essence of Zen through the use of bold lines, abbreviated brushwork, and dynamic imagery.

### VISUAL ENLIGHTENMENT: ZEN PAINTING IN JAPAN

Although the seeds of Zen painting and calligraphy were sown in China, this genre attained full flower in Japan. Masterpieces of Zen art by such monks as Ch'an-yueh, Lian-K'ai, Yu Chien, Mu Ch'i, Chi-weng, Yin-t'o-lo, and I-shan I-ning were enthusiastically imported to Japan during the twelfth and thirteenth centuries and a number of native artists, for example, Kao Shonen and Mokuan Reiun, studied on the mainland.

It was the outstanding artist Sesshū Tōyō (1420-1506) who established the independence of Japanese Zen painting. Sesshū's paintings were technically superior, of course, but his brushwork additionally displayed a freshness and directness largely absent in the works of professional and literati artists. Sesshū had only the most tenuous relationship with the academy of professional artists, and he was among the first to open his commissions to anyone who asked. Furthermore, his paintings were original interpretations, not merely imitations of classical subjects, based on careful observation of—and deep insight into—the natural world. Tradition has it that Sesshū would begin a painting session by first contemplating the sea and mountains from his studio window. After a cup of rice wine, he would play his bamboo flute until his mind was properly composed. Only then would he put brush and ink to paper.

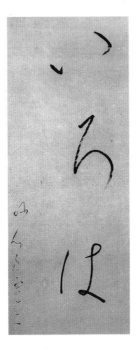 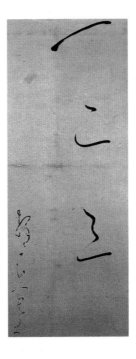

figure I-a & b.
*I-ro-ha Ichi-ni-san.*
Ryōkan, 1758-1831.
(Private Collection)

11

During the first three centuries of its existence in Japan, Zen was primarily a creed for samurai and cultured aristocrats, but by the sixteenth century Zen masters began to take an active interest in the material and spiritual welfare of ordinary folk. The emphasis on "People's Zen" dramatically expanded the scope of Zen calligraphy and painting. Previously, Zen calligraphy consisted primarily of difficult Buddhist verse, sayings of the Patriarchs, and selections from ancient texts. Painting centered on portraits of the Buddha, Bodhisattvas, Bodhidharma and the Chinese Patriarchs, and famous events in Zen history. In People's Zen, however, painting and calligraphy became a kind of ultimate folk art—one of the most famous examples of Zen calligraphy is a set of scrolls brushed by Ryōkan (1758-1831) for an illiterate farmer: *i-ro-ha, ichi-ni-san,* "A-B-C, One-Two-Three" (fig. I). Other masters such as Hakuin, Sengai, and Tesshū employed brush, ink and paper to create enlightened art which illuminated every aspect of the human experience.

## HAKUIN, SENGAI, TESSHŪ: MASTERS OF ZEN ART

Hakuin (1685-1769) was adept at brushwork in his youth but painted almost nothing for forty years after viewing a totally unselfconscious piece of Zen calligraphy by the master Daigū (or, according to other accounts, by Ungō ). Thinking to himself, *"This is the result of true enlightenment,"* Hakuin burned his brushes and calligraphy manuals, dissatisfied with the pretense of his own efforts; it was not until his mid-fifties that he felt confident enough of his own insight to paint seriously again. In the last three decades of his life, Hakuin produced a vast number of pieces on an extraordinary variety of subjects, ranging from full-color "visual operas," with a large cast of characters and various themes and sub-plots, to roughly drawn cartoons.

Along with traditional themes brushed in a strikingly fresh, highly personalized manner, Hakuin drew inspiration from other schools of Buddhism, Confucianism, Shintōism, Taoism, folk religion, and scenes taken from everyday life; his calligraphy, too, encompassed more than the words of the Buddhas and Patriarchs—it embraced nursery rhymes, popular ballads, humorous verse, and bawdy songs from the geisha quarters. Hakuin's paintings were, as one of his seals reads, "paintings that liberate beings" *(hōjō-e),* works of art to bring the viewer to a deeper understanding of his or her own nature and the world at large.

In a sense, Hakuin's work was "anti-art," that is, not consciously created to be "beautiful" or "decorative." In fact, Hakuin never corrected mistakes or omissions in his calligraphy and if the pieces had drips or catpaw tracks on them so much the better! On large pieces, Hakuin frequently did an outline first but instead of erasing it, he drew over the outline, creating a kind of "3-D" effect.

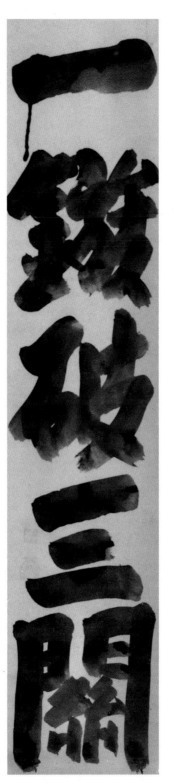

An example of Hakuin's distinctive brushwork is shown in figure II. Waste is abhorred by Zen masters, and ink would never be thrown away. In this calligraphy, Hakuin used old ink that had partially congealed. With tremendous power and extension, Hakuin slowly brushed a visual *kōan*—"*A Single Arrow Shatters Three Barriers*"—with the leftover ink. The ink splotches give the characters a three-dimensional quality, and when the ink happened to run when the piece was being lifted, that drip became a part of the creative process. Incredibly robust, this piece illustrates the Zen approach to art: bold, forceful, and free of artifice.

Sengai (1750-1838) led a happy-go-lucky life, freely associating with all manner of people, ranging from mighty lords to vagrants, from aristocratic ladies to lowly pleasure girls, instructing all, mostly through the medium of Zen art, with a delightful combination of worldly and transcendental wisdom.

As with Hakuin, it is not clear where Sengai developed his skill as an artist; he, too, probably studied informally with artist friends and disciples. Also similar to Hakuin, Sengai did not devote himself to Zen art until he was in his sixties.

Sengai wrote this about his brushwork: *"Worldly painting has a method: Sengai's paintings have no method. As Buddha said, 'The True Law is no Law.'"* That is, each piece was created in the here and now in response to a particular situation, just as Buddha tailored the content of his talks to the ability of his listeners, speaking to the moment rather than reliance on sermonizing. Zen art is never drawn after abstract models or ideal forms: it is always centered in the present reality.

Since Sengai's art addressed the realities of life he produced an enormous number of pieces on every imaginable subject—name it and there is probably a Sengai painting of the theme. (Sengai received so many requests that he complained on one of his paintings: "People must think that my study is some kind of toilet,

they bring so much paper here.") Perhaps Sengai's supreme contribution to the perfection of Japanese Zen art was his insistence that Buddha-nature has a physical as well as a spiritual side that cannot be ignored or explained away. Hence, Sengai did cartoons of people (and Buddhas!) passing wind and answering the calls of nature. One such self-portrait shows Sengai squatting in a field relieving himself. The inscription jokes, *"I hope no one comes!"* Even distinguished abbots have to answer nature's calls; without their fancy titles and magnificent garments our leaders are the same as any other human being. Nor did Sengai avoid the question of sex. Sengai's attitude towards human emotions is summarized by this Zen verse:

> *Falling in love is dangerous,*
> *For passion is the source of illusion;*
> *Yet being in love gives life flavor*
> *And passions themselves*
> *Can bring one to enlightenment.*

> translated by John Stevens

This Zen master's "visual sermons" have a powerful effect and it is said that a greedy merchant mended his ways after viewing a painting of Kannon, the Goddess of Compassion, by Sengai.

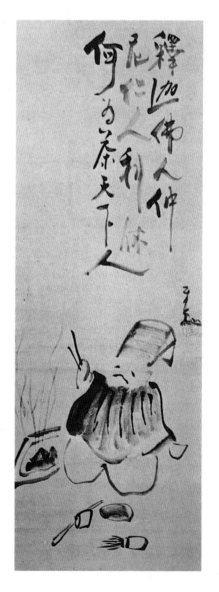

Sengai's "joy of enlightenment" can be sensed in his humorous portrait of Sen no Rikyū, founder of the tea ceremony (fig. III). While standard portraits of Rikyū show him in strictly formal dress against a meticulously ordered background and with a dignified expression, here Sengai captures Rikyū at his leisure. Notice how Rikyū's utensils are scattered about in delightful disarray; the tea master is obviously enjoying himself in an unbuttoned manner. An occasional lapse in procedure is permissible—in fact, necessary, for nothing should be taken too seriously. The inscription, too, indicates that each person must walk to his or her own drummer: *"Shaka was a Buddha (in India), Confucious was a sage (in China), and (here in Japan) we have Rikyū, a great tea master."*

Tesshū (1836-1888) was a layman

figure III.
*Tea Master Rikyū.*
Sengai, 1750-1838.
(Private Collection)

14

who combined Zen enlightenment with family life, public service (he was Emperor Meiji's most trusted aide), and social welfare. Tesshū's output of Zen art is truly staggering—conservatively estimated at a *million* pieces. The primary reason for such astounding productivity was to raise money for the restoration of temples, for disaster victims, and other worthy causes.

During the last eight years of his life Tesshū averaged five hundred pieces of Zen art a day; if necessary he could turn out more than a thousand pieces in twenty-four hours (his record was 1,300). On those occasions when Tesshū needed to brush a large amount of calligraphy to be donated to charity, he would begin right after morning *kendō* training (Tesshū was one of Japan's greatest swordsmen). Five or six assistants would prepare the ink, set up the paper, dry the finished sheets, and so on, while Tesshū wielded the brush. Except for a few minutes break to have a simple meal of rice and pickled plums, Tesshū would continue well past midnight. *"Gather all things in heaven and earth in your brush and you will never tire,"* Tesshū told his disciples as they dropped, one by one, from exhaustion.

Tesshū's calligraphy was in such demand that to maintain order his disciples had to hand out numbers to scores of people who came daily to ask for a piece. One day his disciples were so angered by a butcher's request for a signboard they refused to let him in. (In those days, most Japanese Buddhists were vegetarian.) Tesshū overheard the commotion and came out. *"If it helps his business, that will be fine,"* he lectured them sternly. *"My calligraphy is not for sale, nor is it a commodity to be bartered; anyone who comes here with a request, regardless of what it is, should not be turned away."* Even today, there is a well-known bakery on the Ginza in Tokyo that proudly displays a reproduction of the signboard that Tesshū wrote for the original shop over a hundred years ago.

Although there was no charge for Tesshū's brushwork, most petitioners offered something, either a gift or money. Whenever Tesshū received a money envelope he placed it, unopened, in a special box. When a needy person or persons appeared, Tesshū would rummage through the box and pull out the necessary amount. The sale of Tesshū's Zen art raised a fortune for others but not a yen for himself.

Each time Tesshū brushed a piece, he would silently recite a Buddhist vow: *"Sentient beings are innumerable, I vow to save them all."* When an acquaintance commented, *"You certainly have brushed a lot of pieces,"* Tesshū replied, *"I've just begun. It will take a long time to reach thirty-five million"*—the population of Japan at that time.

One day a noted calligrapher visited Tesshū. After outlining his elaborate preparations, his careful selection of instruments and paper, and his special techniques, the calligrapher asked Tesshū the

method the Zen master followed.

*"The method of no-method,"* Tesshū told him.
*"I don't understand,"* the puzzled calligrapher said.
*"Which do you think is the better carpenter: one who
can only work with exactly the right tools, or one
who can make do with whatever is on hand?"*

Looking at an example of Tesshū's calligraphy (fig. IV-a&b), we can see how the spirited brushwork seems to flow up and down the paper in an unbroken stream. It has a vitality that almost crackles with energy. Unlike many Zen artists, Tesshū was a master of technique as well as a spiritual giant, and his work is considered to be the finest Zen art of the modern era.

## VISUAL ENLIGHTENMENT:
## THE CONTEMPLATION OF ZEN ART

Zen art is meant to be contemplated rather than merely viewed. Originally, each piece of Zen art was reverently displayed in the alcove of a temple or in the rooms of a master's disciples and parishioners, speaking silently but eloquently to every person who sat before it. In modern Japan, exhibitions of Zen art are sometimes held in a meditation hall, allowing one to sit quietly and gaze calmly at a piece. Zen art hangs today in homes all over the world, bridging cultural and conceptual barriers, proclaiming a message of liberation from pettiness, greed, and delusion.

The creation of Zen art depends on two essential factors: state of mind *(shinkyō)* and level of enlightenment *(gokyō)*. Indeed, in Zen art, one has to be a masterpiece in order to create a masterpiece—Zen art is an expression of the Buddha-mind. The depth and breadth of a master's enlightened vision is revealed through the medium of brush, ink, and paper as "Zen activity" *(zenki)*. The freedom, naturalness, profundity, vitality, power, stability, warmth, and refinement that we sense in a genuine example of Zen art all derive from Zen activity. A master's spirit permeates, and radiates from, a work of Zen art and each viewer can actually encounter a living presence in the brushstrokes.

While the primary purpose of Zen brushwork is to instruct and inspire, it does have a distinctive set of aesthetic principles. In his book *Zen and the Fine Arts*, Shin'ichi Hisamatsu distinguished seven characteristics of Zen art: asymmetry, simplicity, austere sublimity or lofty dryness, naturalness, subtle profundity or deep reserve, freedom from attachment, and tranquility. Zen, however, cannot be so easily characterized; there are, for example, paintings of perfectly symmetrical Zen circles, highly complex "visual operas" by Hakuin, and a number of erotic works by Zen artists. Actually, the most important element in Zen art is *bokki*, the flow of energy *(ki)* in the ink *(boku)*.

16

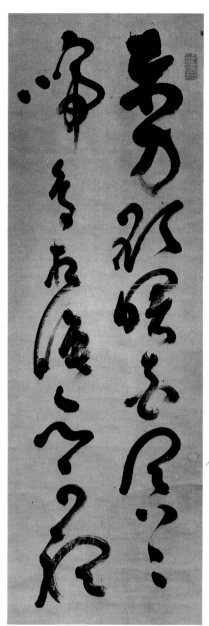

*Bokki* is the vibrant force we perceive when we contemplate a piece of Zen art. It is the *anima* of the work, the heart and soul of the brushstrokes. *Bokki* is as much felt in the pit of one's being as perceived with the eyes. Each line of a work of Zen art must manifest clarity, liveliness, intensity, gravity, sensitivity, suppleness, extension, and, lastly, technical competence. In short, the best Zen art is true *(shin)*, beneficial *(zen)*, and beautiful *(bi)*.

It is well understood in the Orient that contemplation of art fosters awakening no less than sitting in meditation, studying a sacred text, listening to a sermon, or going on pilgrimage. Zen masters applied their insight to painting and calligraphy to inspire, instruct, and delight all those who choose to look.

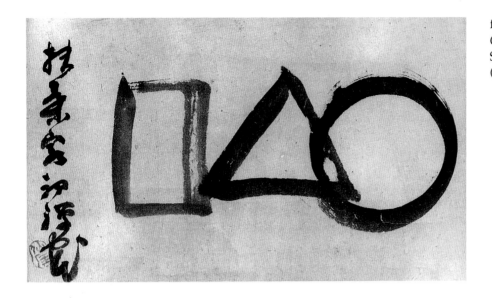

figure V.
*Circle, Triangle, Square.*
Sengai, 1750-1838.
(Idemitsu Museum)

## CIRCLE, TRIANGLE, SQUARE
## BY SENGAI

This is likely the most famous Zen painting in the world (fig. V). Various interpretations of this enigmatic work have been put forth over the years, including one that holds that the painting means nothing at all—Sengai drew the three shapes to give children who flocked to his hermitage a geometry lesson. Others view the work as an abstract representation of the Zen life: the mind of enlightenment (the circle) is expressed through *zazen* (the triangular meditation posture) within the temple walls (the square). Or perhaps the circle symbolizes infinity, the triangle the human world, and the square myriad phenomena. Or maybe the circle stands for formlessness, the triangle the three aspects of human existence (body, speech and mind), and the square the four elements (earth, water, fire and air). Or could it be that the circle represents the "empty" teaching of Zen, the triangle the mysteries of Shingon esotericism, and the square the ordered philosophy of Tendai Buddhism? Or is this a diagram of the universe's physical composition: "liquid body" (circle), "vapor body" (triangle), and "solid body" (square)? Sengai had some knowledge of Christianity—he read the works of the early Jesuit missionaries and visited churches in Nagasaki—so this Zenga could even be interpreted in Christian terms: the circle represents the perfection and eternal existence of God, the triangle stands for the Trinity, and the square is an emblem of the confines of earthly existence.

What do you see?

# LOOKING AT ZEN ART

by Alice Rae Yelen

## ZENGA:
## BRUSHSTROKES OF ENLIGHTENMENT

The artistic and spiritual strength of Zenga—Japanese for Zen painting—is powerfully demonstrated by seventy masterworks in the exhibition *Zenga: Brushstrokes of Enlightenment*. Primarily from the Edo Period (1615-1868) but extending through the mid-twentieth century, this collection of paintings was inspired by the experience of Zen Enlightenment. While the majority of Zen painters were Zen Buddhist monks, the exhibition also includes works by laymen embued with the Zen spirit, and by monks and a nun from other Buddhist sects. Zenga's energetic action-packed brushstrokes, giving simplified visual form to Zen concepts, find a sympathetic reception in Westerners accustomed to modern abstract painting. Yet, a majority of the works in the exhibition predate non-representational art by one to three centuries. Moreover, Zen masters never considered their painting to be either abstract or "art for art's sake," as it is the Zen masters' spiritual zeal which is expressed in their brushstrokes. Reflecting the unique Zen Buddhist vision, spontaneous brushwork can be a path to enlightenment.

Designed to appeal to the connoisseur and the general public, this exhibition introduces over fifty previously unpublished images by acclaimed Zenga masters, recognized disciples and yet unstudied artists. The latter are included to increase public awareness, scrutiny, and scholarship of later Zen painting.

Artworks are presented in a thematic arrangement of subjects typically found in Zen painting in order to familiarize the viewer with the religious and cultural significance of each work, as described in the catalog entries and essay, "The Spiritual Dimensions of Zen Art." The grouping of like subjects in chronological order, by varied artists, encourages a comparative aesthetic judgement of these images. Usually without understanding the meaning of the religious iconography and often unable to decipher calligraphy, the Western viewer approaches Zenga from a purely aesthetic perspective, perhaps based on exposure to twentieth-century abstract painting. This is in contrast to the Japanese who, by understanding the religion, culture and language of Zenga may appreciate these works differently. While this essay places Zenga in historical perspective, it emphasizes aesthetic appreciation of Zen painting in its thematic context.

*Zenga: Brushstrokes of Enlightenment* is the first Zen painting exhibition in the United States to be organized by placing works in their cultural and religious context, rather than in the traditional art historical format. In this arrangement, Zenga emits a remarkable power based on its completeness, in which art and spirituality emerge triumphantly and simply as one.

## HISTORICAL OVERVIEW

Zen Buddhism was brought to China from India in the sixth century by the Indian monk Bodhidharma, known to the Japanese as Daruma, the Grand Patriarch. Later, in the thirteenth century, Zen was transmitted to Japan. Although all Buddhists seek enlightenment, Zen differs from other Buddhist sects in its belief that individual enlightenment is achieved through discipline, *zazen* (meditation), and understanding of one's inner self rather than through rote intellectual study of Buddhist *sutras* (texts). Historically, the strict beliefs of traditional or doctrinal Buddhist sects were reflected in their stylized paintings which can be termed "mainstream Buddhist iconography." The tightly composed *sutra* cover (fig. I), which serves as a decorative illustration to the religious scriptures, exemplifies highly defined Buddhist philosophy and its related painting style from which Zen Buddhism deviated. Fashioned of cut-gold applied to an indigo background and decorated with symbolic lotus flowers (which signify purity amidst corruption), this cover displays recognizable Buddhist deities, with elegant refinement. Such stylized artistic renderings of the Buddhist pantheon are depicted within the canons of religious painting, canons in which digression from the exact formula represents a divergence from the doctrinal Buddhist ideal. Concurrence with prescribed form and controlled technique requires disciplined artistic training. Formal Buddhist iconographic painting, which often employs brilliant colors and precious metals, has remained the predominant form of Buddhist painting from its sixth-century inception in China to the present day.

Zenga represents the spiritually and artistically expressive art of Zen masters whose free, personal interpretations, contrasted in style with the rigidity of traditional Buddhist painting. Zen painting and calligraphy, emphasizing spontaneous, individual expression, are primarily monochromatic, achieved through the application of *sumi* (black ink) onto paper or occasionally silk. Zen masters were not trained officially as artists. They attended no painting workshops or schools and thus subscribed to no predetermined canon of proportions or style. Artistic expression of their Zen beliefs in a free style of their own choice not only was acceptable, but encouraged as a method of increasing self-awareness.

Zen masters believe in the direct transmission of the Buddha-mind from teacher to pupil. Some teachers relied on enigmatic philosophical questions known as *kōans* (cat. no. 70) to jolt their students into achieving their most important goal, self-realization and insight into their own inner natures. These paradoxical *kōans* defy logic and serve as a mentor's aid to direct his student to deep, unanticipated insight. One famous but puzzling *kōan* used by the great Zen master Hakuin was *"What is the sound of one hand clapping?"* Unlike other Buddhist sects whose route to enlightenment is gradual and based on pursuit of graded knowledge, Zen enlightenment is sudden and spontaneous, often a startling

figure I.
*ddhist Sutra Cover*
Heian Period,
circa 13th century

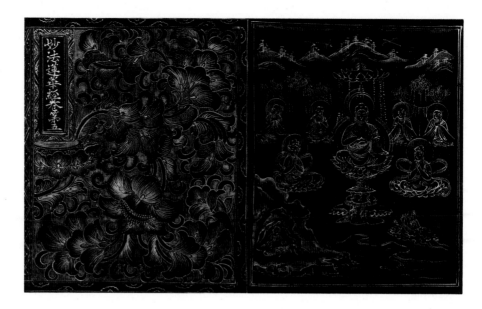

response to a simple event, such as the ringing of a bell. The moment of enlightenment cannot be calculated, measured or predicted; it comes unexpectedly after years of training and commitment, when the individual is ripe for the experience. It is the expression of this Zen spirit which is captured in the vibrant, spontaneous brushstrokes of Zenga.

During the Muromachi Period (1392-1568), shortly after the introduction of Zen Buddhism into Japan, Zen became the principal religious and cultural influence in the country, affecting education, government and the arts. This resulted in commissions for Zen painters by the chief patrons of the time: the aristocracy, government officials, feudal lords, wealthy samurai and temples. The major Muromachi Period art forms were Zen-inspired. Many of these professional artists were also monks, whose primary commitment was to painting rather than Zen teaching. They excelled in *suibokuga* (ink painting) often of landscapes, and displayed more individual expression in their brushwork than had previously appeared in traditional Buddhist painting. Muromachi Zen artists also signed their paintings and calligraphic inscriptions, unlike doctrinal Buddhist painters who often left their works unsigned.

In the subsequent Momoyama (1568-1615) and Edo Periods (1615-1868) the influence of Zen Buddhism declined in aristocratic and government circles. Thus, the prestige confirmed upon Zen affiliates also deteriorated, and eventually altered the future direction of Zen art. Zen masters began to internalize, practicing Zen and simultaneously creating art solely from within, for their parishioners and priestly students. This resulted in a more instructive, individualistic and expressive art. Unlike their Muromachi predecessors, Edo Period Zen monks no longer received patronage and commissions, as the officials and newly arisen merchant patrons transferred their support to artists of the many other established and new painting schools such as *Kanō, Tosa, Shijō,*

21

*Rimpa, Ukiyo-e* and *Nanga* which flourished during the approximately 250 years that Japan remained closed to the outside world. While much of Muromachi Period painting was Zen-inspired, Zenga represented only a small fraction of the varied artistic output of the Edo Period.

Edo Period Zen masters were not professional artists; they painted solely in pursuit of their Zen beliefs. They almost never sold their works nor sought artistic acclaim from the outside world. Individual artistic expression in the early Edo Period emerged within the framework of the diverse life styles of the Zen masters and their affiliation with the three main Zen sects. For example, Fūgai (1568-1654) of the Sōtō sect, the earliest artist represented in the exhibition, largely avoided temple life, living as a hermit, following his own Zen style. Fūgai's brushwork, usually depicting traditional Zen subjects (cat. no. 3), is delicate, refined, poignant and penetrating.

By contrast, Sokuhi (1616-1671), came as part of a delegation of Chinese monks who introduced the Ōbaku sect to Japan. He chose to live like the majority of Zen monks, as a temple abbot, propagating Zen beliefs to the common people. Ōbaku monks were noted for their bold calligraphy, exemplified by Sokuhi's *Dragon and Tiger* (cat. no. 1).

A totally different expression is seen in the tight, refined quality of the Rinzai monk Daishin's work (cat. no. 39). From Kyoto's famous Daitoku-ji, Daishin's painting and calligraphy represent the well defined style of his illustrious temple predecessors.

This exhibition focuses on the work of Hakuin (1685-1769) and his followers, as well as other individual post-Hakuin Zen painters of the Edo Period, with selected examples extending into the mid-twentieth century. Hakuin revitalized Zen Buddhism in Japan through his writings and teachings, and became recognized as the most influential Zen teacher of his era. Abbot of Shōin-ji and Ryūtaku-ji, small temples at the foothills of Mt. Fuji situated far away from metropolitan centers, Hakuin's religious impact was spread throughout Japan by his numerous religious followers. Hakuin had three main disciples: Suiō (1716-1789); Tōrei (1721-1792); and Reigen (1721-1785). Other followers and their disciples also disseminated his teaching (fig. II). The great master became a Zen monk at the age of fifteen, but did not begin painting in what art historians today call his early period until after age sixty. Hakuin never devoted himself exclusively to painting; his chief concern was always Zen study. Nevertheless, by the time he attained his fullest artistic expression in his eighties, he was a painter and calligrapher of the highest order. Today, Hakuin is considered the most important Zen monk and Zen artist of the last three centuries.

Another important Edo-period Zen master was Sengai (1750-1838),

figure II.

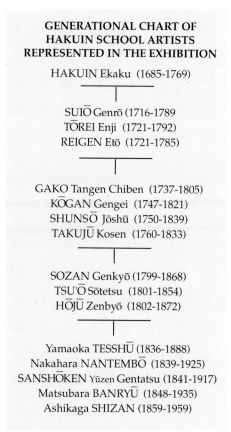

**GENERATIONAL CHART OF
HAKUIN SCHOOL ARTISTS
REPRESENTED IN THE EXHIBITION**

HAKUIN Ekaku (1685-1769)

SUIŌ Genrō (1716-1789
TŌREI Enji (1721-1792)
REIGEN Etō (1721-1785)

GAKO Tangen Chiben (1737-1805)
KŌGAN Gengei (1747-1821)
SHUNSŌ Jōshū (1750-1839)
TAKUJŪ Kosen (1760-1833)

SOZAN Genkyō (1799-1868)
TSU'Ō Sōtetsu (1801-1854)
HŌJŪ Zenbyō (1802-1872)

Yamaoka TESSHŪ (1836-1888)
Nakahara NANTEMBŌ (1839-1925)
SANSHŌKEN Yūzen Gentatsu (1841-1917)
Matsubara BANRYŪ (1848-1935)
Ashikaga SHIZAN (1859-1959)

compiled by John Stevens

a prolific artist from the southernmost island of Kyūshū, who created many cartoon-like, Zen inspired paintings (cat. no. 27). Some noted Zenga artists were not members of the Zen sect. Jiun (1718-1804), of the Shingon sect, created strong, bold calligraphy replete with the Zen spirit (cat. no. 64), and Gōchō (1749-1835), of the Tendai sect, frequently depicted traditional Zen themes in his painting and vibrant calligraphy (cat. no. 29).

Zen art is part of Zen training. The practice of calligraphy is an important part of the disciplined Zen life. Calligraphy is considered to be active meditation by the painter, while the visual depiction serves as a teaching tool for others. Paintings often were given as gifts to students and parishioners to serve as a source of Zen inspiration. Thus, Zen masters quite naturally selected subjects and characterizations of Zen life as themes for their work. It is through such iconography that this exhibition explores the artistic accomplishment and spiritual impact of the Zen master's brush.

## DARUMA

*Zenga: Brushstrokes of Enlightenment* is organized thematically into five sections designed to introduce viewers to the subjects and ideas central to Zen thought and life: "Daruma: The Grand Patriarch of Zen;" "Zen Heroes;" "Zen Teachings;" "Zen Calligraphy;" and "Zenga: The Contemplative Art." Each category is presented chronologically. The first section presents twenty-two images of the most frequently represented Zen figure: Daruma, The

Grand Patriarch, who brought Zen teachings from India to China. Daruma embodies the Zen spiritual quest, the search for and knowledge of the inner mind, and the rejection of externals. As no one knew what Daruma actually looked like, Zen paintings of Daruma are not historical portraits; rather, they reflect each master's perception of his or her own spiritual experience.

Daruma is presented here in his four traditional poses: Half Body; Side View; On a Rush Leaf; and Wall Gazing (seen from behind while meditating against a wall). Each form symbolizes a special aspect of the patriarch. The combination of clearly delineated facial features and elusively suggested robes in Daruma's depiction emanates from the Chinese visual tradition. By omitting detailed depictions of his robe and underlying anatomical structure, the Zen artist encourages the viewer to look beyond the obvious, the tangible and material and to concentrate instead on the spiritual.

Although united by motif, each Zen artist records his own interpretation of Daruma. Comparison of this subject in similar poses as portrayed by artists spanning three centuries (the early seventeenth through the mid-twentieth) reveals the uniqueness of each master's hand. The range of variety in Half Body Darumas is dramatic. Instructive examples include: Fūgai's deliberating depictions, (cat. nos. 3 & 4); Hakuin's simple, yet profound and serene *Giant Daruma* (cat. no. 2); Shunsō's severe and penetrating image (cat. no. 7); and Hōjū's jocular, pirate-like portrayal (cat. no. 10). Modern renderings, more free-spirited and loosely defined, include Kokai's peaceful, dreamlike depiction (cat. no. 9), Nantembō's whimsical interpretation (cat. no. 23) and Banryū's humorous Daruma (cat. no. 13). The individuality of each artist is apparent, but it is difficult to distinguish the century in which a work was created by examining the image alone.

As the viewer compares these similar images and absorbs the diverse personalities, the subtle differences in style which make

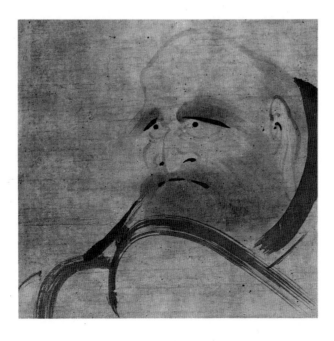

figure III.
*Half Body Daruma*
Fūgai, 1568-1654.
(detail, cat. no. 3)

24

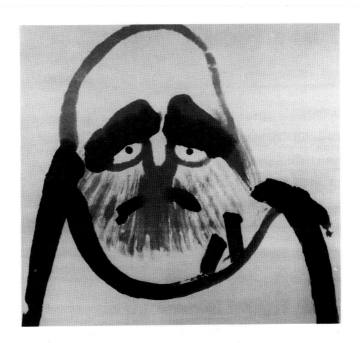

each work distinctive become noticeable: ink tonality, ranging from white to grey to black; textural variation; thinness and thickness of brushstroke; and varied compositional use of space for positioning of the painting, calligraphic inscriptions, artist's signatures and seals. What do these works and the manner in which they were executed reveal about the Zen master as a teacher, as an artist, and as a human being?

A juxtaposition of Fūgai's seventeenth-century *Half Body Daruma* (fig. III), the earliest work in the show, and Sanshōken's twentieth-century *Half Body Daruma* (fig. IV), one of the latest works included, reveals the expressive and stylistic differences in paintings of the same figure, in similar formats, with analogous meaning. The two artists had very different careers. Fūgai was a recluse, who lived mostly in caves; Sanshōken by contrast was abbot of one of the largest temples in Kyoto. Fūgai's Daruma is a piercing portrait while Sanshōken's is a humorous caricature. Seemingly contrasting characteristics, both are typical of Zen painting.

Fūgai's depiction is characterized by finely drawn, pale grey lines which outline Daruma's eyes, eyebrows, ears, nose, mouth and beard, realistically portraying facial features, knitted in a stern, poignant expression. A few thin, precise, black lines describe his eyelids, mouth, inner ear and nostrils, while two black dots portray his intense, penetrating eyes. Daruma occupies the bottom half of the composition where Fūgai employed delicate lines and precise brushstrokes to create an image of spiritual refinement. The depth and severity of Fūgai's Darumas reflect his own reclusive, yet contemplative existence.

Painting on silk, Sanshōken relied on minimal broad strokes of a wet brush to create a Zen-like cartoon. The facial features of his

Daruma are rendered in thick, rough grey strokes contrasted with wide, black strokes for the lower eyebrows, nostrils and robe. The thick eyebrows, a skillful melange of wet, black and grey brushstrokes, illustrate the visual effect of ink bleeding into the silk background and reveal the woven texture of the shiny fabric. As in all Zenga, the color and texture of the material on which the simple ink is brushed is incorporated into the painting's composition. Daruma's robe is larger in proportion to his face in the Sanshōken painting, but is suggested by only three connecting strokes. Here maximum expression is achieved with minimal brushwork, a characteristic of Zenga. Sanshōken's reputation as a big-hearted and humorous monk is reflected in his joyous, playful, loosely brushed rendering of Daruma.

In Zenga the transmission of enlightenment from master to pupil often is referred to as "a doctrine beyond words." It is fitting that a doctrine beyond words employs visual imagery as a key component. Visual imagery sparks the imagination beyond the limitation of words and can expand the boundaries of concepts and ideas. Zen images are intuitive, simultaneously introverted and extroverted, controlled and yet spontaneous—qualities descriptive of and necessary to Zen enlightenment.

Zen masters selected disciples, and students sought mentors on the basis of spiritual enlightenment, not artistic ability. Spiritual lineage can thus be clearly defined by the relationship of a pupil to his mentor as shown in the Generational Chart of Hakuin School Artists (fig. II). Yet visual exposure to the legacy of Zen art came to the practitioners in many forms: through works Zen masters did for students and parishioners; through works done by teachers other than their own (whom students sometimes met on pilgrimages); and through the Zen paintings which temples received as gifts from patrons and visiting masters. Students often learned calligraphy in their early years of education, prior to becoming monks. In the monasteries, there were no classes in painting, no institutionalized, one-to-one transmission of artistic technique to parallel the spiritual transfer, and no designated temple hall in which to regularly view or discuss paintings. Painting was an expression of faith, but not necessarily an established part of spiritual training. Although disciples were spiritually influenced by their mentors, they were often artistically influenced to a lesser degree. Each monk's work reflects his own artistic hand. This may be due to the fact that enlightenment, their primary goal, came through individual pursuit, despite a mentor's guidance. The independence of the process required to achieve Zen enlightenment also encouraged monks to seek individuality in creative self-expression.

The artistic influence of a spiritual mentor on his pupil can be evaluated by comparing paintings of similar subjects by master and disciple. Hakuin's *Half Body Daruma* (fig. V-a) and his student Reigen's work (fig. V-b) on the same theme have much in common: general appearance of the Patriarch; shape and position of the line

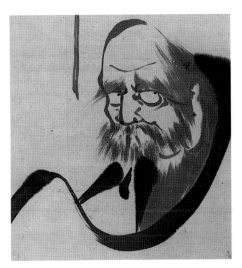
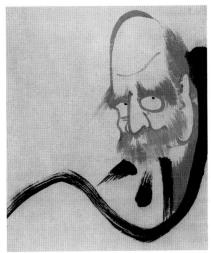

suggesting his robe; and the presence of three dark strokes connecting Daruma's head to the robe. However, Reigen's Daruma is by no means a copy of Hakuin's. It has a more elongated head, utilizes softer greys, a different calligraphic inscription, and less-jagged lines than Hakuin's rendering. Hakuin uses diffused ink to create a fuzzy edge which blends into the paper near Daruma's shoulder. Hakuin's robe line has a greater range of ink tonality whereas Reigen's is consistently darker and the brush skips across the paper surface to incorporate the light background into the brushstrokes. This technique is known as "flying white." Reigen's calligraphy is placed above Daruma's head reaching to the top of the scroll, whereas the head of Hakuin's Daruma is connected to the top of the scroll by a tall vertical line. Although a high degree of influence from Hakuin does exist, a connoisseur can readily distinguish each Zen artist's hand.

Comparison of Hakuin's *Side View Daruma* (fig. VI-a) with the same subject by another of his disciples Suiō (fig. VI-b) also shows the master's influence functioning in tandem with the student's individuality. The general configuration and position of the figure in the picture's format, as well as the facial expression appear similar. Yet in Hakuin's Daruma the nose is more protruded and the light-grey facial strokes are pale in comparison to the medium-grey of his student's darker ink tones; moreover, Hakuin's Daruma is seated on a mat depicted in an array of lines, whereas Suiō's figure indicates no such seat. The shoulder of Hakuin's Daruma again has a skillful interplay of grey and black brushstrokes. Suiō's shoulder and robe show an interplay of short black lines punctuated by black circles—ink seepage from a consistently abrupt brush stoppage indicative of his painting technique. This distinctive line formation is characteristic of Suiō and is unlike Hakuin. It can also be seen in Suiō's *The Chinese Patriarch Rinzai* (cat. no. 36) and *Zen Landscape* (cat. no. 50).

Although the work of Hakuin's two students, Reigen and Suiō, closely reflect their master's visual influence, their respective brushwork, tonality and line quality are distinctively their own, and different from that of one another. These differences demon-

27

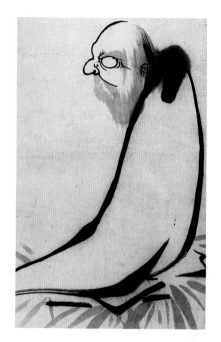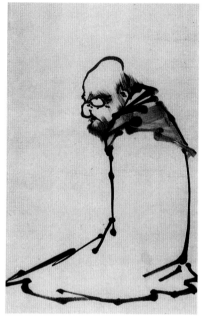

figure VI-a & b.
*Side View Daruma.*
Hakuin, 1685-1769.
(detail, cat. no.14)

*Side View Daruma.*
Suiō, 1716-1789.
(detail, cat. no. 15)

strate that Zenga reflects the inner vision of each Zenga master.

In their disciplined quest for spiritual excellence, Zen masters repeatedly brushed the same images. Eventually, such spiritual focus led to creative artistic spontaneity. Just as their disciplined meditation resulted in sudden enlightenment, so did their repetitive, simple (minimal) painting become and appear spontaneous. Achievement of this dexterity took years. When the master Hakuin was asked how long it took to paint a Daruma, drafted in just a few major strokes he said, *"Ten minutes and eighty years."* The "eighty years" refer not only to the time needed to develop the artistic ability of the painter, but the time required to attain the necessary spiritual self-realization of the Zen practitioner. Since the spirit speaks through the brush, a person who had not achieved inner spiritual development could not paint with the power of an accomplished Zen master.

## ZEN HEROES AND TEACHINGS

Section two of the exhibition is an array of "Zen Heroes," role models for enlightenment and, thus, a pattern for attaining Zen ideals. It concentrates on three Zen favorites: Hotei, a legendary, happy-go-lucky Chinese monk of the eleventh century who is said to have roamed the countryside carrying a huge bag of presents; and Kanzan and Jittoku, a pair of Chinese eccentrics. Kanzan, a poet, usually is shown with a scroll, while Jittoku, a kitchen sweeper in a mountain temple, is depicted with a broom. Other important Zen Heroes, such as Tenjin, the Japanese God of Knowledge, Hitomaro, the God of Poetry, and Kannon, the Goddess of Compassion, are also represented. The latter three personages are used in many other schools of Japanese painting and are not subjects limited to Zenga.

As in the study of Daruma, comparison of the character and brush-strokes of the same subjects, (Hotei, Kanzan and Jittoku) reflect a wide variety of individual expression through the centuries. For example, Fūgai's fine-lined, vertical *Hotei Pointing at the Moon* (cat. no. 24) seems precise, simple and serious when contrasted with Sengai's thicker brushed, humorous, joyful and horizontal rendering of *Hotei Waking from a Nap* (cat. no. 27). As poignancy is consistent in Fūgai's work, so humor characterizes Sengai's renderings in curvilinear whimsical lines.

While some monks such as Fūgai depicted primarily traditional Zen subjects, Daruma and Hotei, others like Sengai established a varied repertoire of themes including those appropriated from sources other than Zen, such as *Lao T'zu Riding on an Ox* (cat. no. 35), *Three Gods of Good Fortune* (cat. no. 49), and *Zen Landscape* (cat. no. 51). Any subject relating to the life of a Zen-inspired master was considered an acceptable painting theme. It was the special interpretation of an image that gave it a Zen quality, not just the subject itself.

Thus the third section of this exhibition explores "Zen Teachings" in renderings of a wide variety of themes—Practice and Enlightenment, Visual Sermons, Zen and Nature and Mt. Fuji.

Visual sermons are portrayed through a mixture of Zen imagery. Although all Zen works were designed to impart Zen principles, this selection provides visual clarification of Zen beliefs. For example, the painting *Blind Men on a Log Bridge* (cat. no. 46) by Hakuin may be philosophically linked to man enduring the tasks of daily life without the advantage of enlightenment.

*Treasure Boat* by Hakuin (cat. no. 48), reflects both the symbolic and visual depth of Zenga's seemingly minimal brushwork. The boat is piloted by Fukurokujū, God of Longevity, and is outlined in dark brushstrokes formed by the Chinese ideographic character for "long life." The boat contains four symbols of good fortune: a lucky raincoat, a wide hat, the magic mallet (the Far Eastern version of Aladdin's lamp) and a good-luck bag filled with riches. Zen paintings are often accompanied by a *san* (a poetic inscription), written either by the artist or by some other individual, but always designed to clarify the meaning of the central image and enhance its composition. The *Treasure Boat* inscription prepared by Hakuin reads:

> *"Those who are loyal to their lord and devoted to*
> *their elders will be presented with this rain coat,*
> *hat, mallet and bag."*
>
> translated by John Stevens

In other words, one who is sincere and considerate in his or her dealings with fellow human beings will be blessed with wealth and good fortune. Disregarding the feelings of others will eventually

lead to ruin. The message is deep and universal, whereas the painting's composition is light and buoyant. The *san* positioned in the upper left corner is brushed with soft thin lines which balance the thicker and darker strokes of the boat in the picture's bottom right.

## ZEN CALLIGRAPHY:
## AESTHETIC ARRANGEMENTS AND MEANING

An examination of Zen calligraphy constitutes the fourth section of the exhibition. While Zen masters rarely had formal instruction in painting, their extensive experience with calligraphy as part of their Zen training familiarized them with brush, ink, and paper. They painted monochromatic and dynamic calligraphic statements, which expressed their Zen doctrines and beliefs. For example, single and double-line calligraphic characters centrally positioned as the subjects of works may implore the viewer to "Always Remember Kannon," Goddess of Compassion (cat. no 33).

Historically, calligraphy has had a significant presence in Japanese painting. Originating in China, in Japan from the Heian Period (794-1185) to the present, it has been considered one of the four arts of the cultured person, along with poetry, painting, and music. Calligraphy plays an important role, too, in the overall design and meaning of Edo Period Zen painting, where there is more visual interplay between calligraphy and image than in any of the other painting schools which flourished simultaneously. To the present day, calligraphy in Japan popularly retains the stature of a greatly appreciated fine art form, and is thus perceived differently than calligraphy currently is in the West.

As a key compositional element, calligraphy can be used in three ways. It can be the central image and subject, exemplified by all the eighteenth to twentieth-century works in the calligraphy section of this exhibition. Calligraphic centerpieces often appear unadorned by other inscriptions, with devotion of the entire picture plane to the artists' configuration of characters. Examples include Jiun's eighteenth-century *Two Line Calligraphy* (cat. no. 64); Tōrei's eighteenth-century *Calligraphic Talisman* (cat. no. 63); and Rengetsu's nineteenth-century *Tanzaku Poems* (cat. no. 65). Calligraphy can serve as an inscription included to enhance a painting's central pictorial image, visually and substantively, as seen in Hakuin's *Treasure Boat* (cat. no. 48); or it can serve as both, when a calligraphic arrangement acts as the work's main image embellished by another calligraphic inscription, as in Hakuin's *Virtue* (cat. no. 61). In unusual instances there is an absence of any inscription and only the artist's signature and/or seals accompany the visual depictions. Examples include Shunsō's nineteenth-century *Mt. Fuji* (cat. no. 55), Kōgan's eighteenth-century *Arhats, Buddhist Saints of India and China* (cat. no. 34) and Onisaburō's twentieth-century *Side View Daruma* (cat. no. 17).

Photograph by Kurt A. Gitter

Pure calligraphy was the most prevalent Zen painting format, as all monks were trained in such writing. Yet pictorial images with a calligraphic inscription are also quite common. Zenga calligraphic inscriptions usually were brushed by the image maker, although traditionally in Japanese painting, inscriptions could be added by colleagues at the time the painting was made, or even years or centuries later to enliven, strengthen, comment on, authenticate or enhance the work. With the exception of Fūgai's *Daruma on a Rush Leaf* (cat. no. 22) and Chingyū's and Shunsō's *Kanzan and Jittoku* (cat. nos. 28 & 31) all inscribed works in this book were drafted by their image makers. Generally the central image was drawn first, and the poetic inscription added.

The artistic interchange between calligraphic inscription and pictorial image appears gracefully intertwined in a variety of creative spatial arrangements which balance content and composition, and thus confirms the artistic sensibility of the Zen master. Image and inscription may be spatially separated or, less frequently, physically connected. Ideally, the image and inscription are balanced but occasionally the image dominates; more rarely the inspiration predominates. In Fūgai's *Hotei Pointing at the Moon* (cat. no. 24) the rounded happy eccentric's figure is positioned in the bottom left corner of the scroll, juxtaposed to the rectangular poetic inscription placed diagonally and separately in the scroll's upper right corner. The central vertical section of the background negative space separates the equally weighted image and inscription, which are stylistically similar and contribute to an aesthetically balanced work. In Daishin's *Wall Gazing Daruma* (cat. no. 18) a two-line vertical inscription in the top right center half of the work is brushed in small, precisely drawn characters placed

31

parallel to the artist's signature and seal in the scroll's top left. Centrally positioned in the scroll's bottom half directly beneath the inscription and signature, yet separated by negative space, is an outline of Daruma gazing at a wall. Although equal space is allocated to both the image and inscription, the shape and richness of ink which create the image make it appear as the dominant feature of the work. A more exaggerated example of image dominance over inscription exists in Sozan's *The Japanese Patriarch Daitō Kokushi* (cat. no. 37), where the begging monk occupies three quarters of the scroll and is crowned by a small delicate inscription. Inscription dominated by image is far more common than image dominated by inscription, the latter as exemplified by Nantembō's *Half Body Daruma* (cat. no. 11). Nantembō's broad, bold, black calligraphic inscription runs energetically and diagonally from the top right corner to the left center of the scroll where it meets a characteristic heavy black line splashed in ink. This thick, eruptive brushstroke traces the side and bottom of the Patriarch's face, delicately painted in pale greys, and becomes the line suggesting Daruma's robe. It is the forcefulness of the dynamically drawn inscription, here physically joined with and emphasized by the lower robe line, which suggests that the inscription dominates the image. This is not achieved by excessive allocation of space, rather it results from the qualities of the highly powered application of thick dark ink strewn across the scroll. This highlights the inscription and creates a strong contrast with the very pale grey portrayal of Daruma's facial features.

Calligraphic inscriptions may be placed in less geometrically pre-dictable positions in order to flow gracefully with the design of a painting's central image. For example, a two line vertical inscrip-tion paralleling Nantembō's twentieth-century *Zen Staff* (cat. no. 42) echoes the staff's length, which extends vertically nearly the entire length of the scroll. Calligraphy in Gōchō's *Kanzan and Jittoku* (cat. no. 29), vertically-positioned and softly balanced between the top and bottom of the diagonally placed image, is an integral part of the composition. The diagonally-positioned trees on a mountain top in Reigen's eighteenth-century *Shrine of Tenjin* (cat. no. 52) are visually paralleled by a soft delicate diagonal arrangement of calligraphic characters subservient to the pre-eminent image of the Shintō shrine. Hakuin's eighteenth-century *Hotei's Bag* (cat. no. 26) encircles the inscription written in equally pale, but thinner, strokes than those describing the Zen hero's bag. Placement of image and inscription reflects the individual Zen artist's personal expression and is not a function of the artistic style of the century in which he lives. The many asymmetrical solutions we have observed can be viewed within the context of the traditional Japanese aesthetic, which stresses asymmetry in the design of gardens, architecture and tea-ceremony ceramics.

Despite the Zen monk's achievement of high aesthetic standards it must be remembered that he painted primarily to express religious beliefs and never considered his work as art. The substantive

function of calligraphic inscriptions and subject configurations is mutual reinforcement and enhancement. Reinforcement occurs through the inclusion of a *san* which expands or elaborates the concept of the central image, both when the calligraphy is a direct commentary on the painting and when the image and calligraphy are the same. In Zen art, the central image (pictorial or calligraphic) and the *san* are meant to work as an organic whole. Take, for example, Hakuin's *Virtue* (cat. no.61) calligraphy in which the subject is a single large character meaning "Virtue." The *san* clarifies the Zen master's view of that attribute:

> *If you pile up money for your descendants*
> *They will be sure and waste it;*
> *if you collect books for them*
> *they probably will not read a word.*
> *It is better to pile up virtue unobtrusively—*
> *such a legacy will last a long, long time.*

<div align="right">translated by John Stevens</div>

In Sokuhi's seventeenth-century pair, *Dragon and Tiger* (cat. no. 1) the bold single character above each image directly names them. The unified meaning of image and calligraphy contributes to the presentation of a stronger message. Tesshū's nineteenth-century *Dragon* (cat. no. 66) further simplifies the issue of reinforcement of image and inscription, as the subject is a visual pun. The character for dragon is simultaneously presented as a pictorial abstraction of a dragon. What is a calligraphic character if not an arrangement of the same brushstrokes that create pictorial imagery? The figures

Photograph by Jan E. Watson.

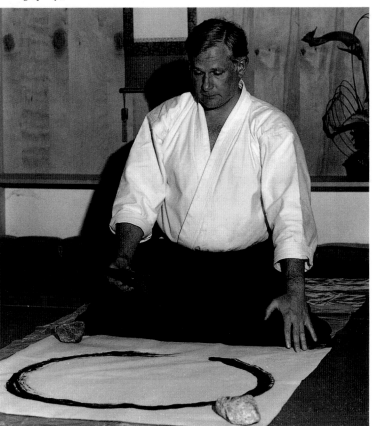

figure VII.
Process of brushing calligraphy with John Stevens.

33

of Daishin's *Hitomaro* (cat. no. 39) and Hakuin's *Tenjin* (cat. no. 38) are created entirely out of calligraphic characters representing the names of the gods, whom they describe pictorially.

## ZEN CALLIGRAPHY: TECHNIQUE AND BRUSHSTROKE

The Zen master's technique employs the application of freshly ground ink mixed with water onto absorbent paper, allowing for little error and no overpainting. He paints with brushes of varying widths on sheets of paper placed on the floor (fig. VII). Seated on his knees, the artist's flexible position allows him to incorporate body force, proper breathing techniques and intense concentration into the execution of brushstrokes. Typically, he paints many works in a session. This method is in marked contrast to the traditional Western process of painting, where an artist paints on an easel, at eye level, one painting over many sessions.

Works made in the beginning of the session, when a brush wet with water was first mixed with the freshly ground *sumi*, tend to be lighter in color (pale greys), while works made toward the session's end, when the wet brush had been repeatedly applied to the rich ink in the stone, tend to be of thicker and deeper ink tone (dark grey to black). Extreme dilution of ink with water creates a paler, washier look no matter when applied. The wetness or dryness, speed and motion of a brushstroke determine the width, tonality, and quality of the line.

The calligraphy style varied widely from formal *Kanji* (Chinese ideograms) executed in a style close to the standard printed form, to a loosely defined cursive style, which is sometimes difficult to read because of the abstraction of the individual Japanese characters.

Zenga masters incorporated the texture and tint of the paper upon which they worked into their compositions. Often images were constructed by just a few strokes, as in Chūhō's *Mt. Fuji* (cat. no. 53) where the background negative space is an integral part of the visual presentation. Shunsō's *Mt. Fuji* (cat. no. 55) reveals the silk woven fabric which absorbed the ink and showcased the visible geometric texture of the work. Ōnisaburō's *Side View Daruma* (cat. no. 17) has a ruffled pattern of black *sumi* and light paper background reflecting the texture of the *tatami* mat floor upon which the paper was placed for painting.

The monk's calligraphic expertise prepared him to depict pictorial subjects, for dextrous brushwork was the basis of both. It is through the Zen master's disciplined but varied application of ink that he establishes his individuality, an external artistic expression of a deeply developed internal vision.

figure VIII-a & b.
Flying white brushstrokes.
*Dragon and Tiger*
Sokuhi, 1616-1671
(detail, cat. no. 1)

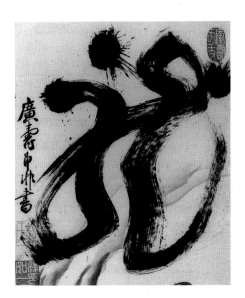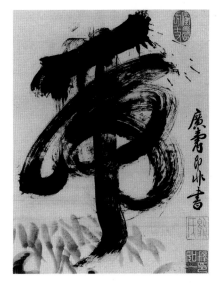

The distinguishing characteristics of each artist are seen in a surprising range of tonal and textural variation in brushstrokes, ranging from black through all shades of grey to "flying white," and executed in thin-to-thick as well as wet-to-dry ink applications. The Zen master's ability to capture and portray an extraordinary spectrum of lights and darks is so superbly and subtly executed that the viewer must accustom his eye to experience these nuances, in order to reap maximum appreciation of the artistic virtues and spiritual depth of Zenga. Consider, for example, the technique "flying white" (fig.VIII-a & b). This distinctive calligraphic stroke is achieved when the calligrapher anchors his brush to paper and moves his arm so quickly that the brush briefly flies off the paper surface, allowing the background paper color to become an integral part of the continued brushstroke. It thus appears as a black line of varying width in which areas of the paper's color shine through. The relative dryness or wetness of the brush and the swiftness of the stroke dictate the degree and quantity of flying white.

Flying white is seen predominantly in broad strokes of calligraphy as noted in Sokuhi's seventeenth-century *Dragon and Tiger* (cat. no. 1) and Jiun's seventeenth-century calligraphic centerpiece (cat. no. 64). It also can be part of an energetically broad sweeping line depicting a non-calligraphic subject such as Chūhō's nineteenth-century *Mt. Fuji* (cat. no. 53). Not all Zen masters employed the technique of flying white. Yet some, like Nantembō, exhibited a propensity for it, as can be observed throughout his work, regardless of theme, in *Half Body Daruma* (cat. no. 11), *Wall Gazing Daruma* (cat. no. 20), *Zen Staff* (cat. no. 42), and *Pair of Two-Panel Screens* (cat. no. 68 a & b).

Each dynamic flying white stroke reflects the artist's arm, body and soul rapidly and vigorously moving through the pictorial plane. Concentrate for a moment on Sokuhi's *Dragon and Tiger* (fig. VIII-a & b), and imagine the amount of physical energy and psychological intensity it takes to create such an image. Flying white does

not appear in the thin, fine lines that create the facial features of either Sokuhi's dragon or tiger, or in those lines which create the small tightly drawn calligraphic *san* of Daishin (cat. no. 18). These thinner, greyer and wetter lines often create a striking contrast in tone, texture and tonality with adjacent flying white lines.

The effects of flying white on the picture plane reveal variety in an artist's skill with the brush. Tesshū's *Dragon* (cat. no. 66) is painted with a single, quite varied brushstroke. The dragon's perky head, facing upward, is composed of thick black strokes and ink splashes, while the central rising loop of the body, brushed in flying white, lends pleasing light coloration to the painting's central composition. The blunt terminating brushstroke of the dragon's tail, a broader, darker and fairly thick stroke, manifests the lines of the brush bristles showing minimal flying white. Variety in the closure of flying white lines can also be seen in the robe lines of Shizan's *Side View Daruma* (cat. no. 16), energetic to the end, and in Chūhō's *Mt. Fuji* (cat. no. 53) which floats onto the white paper background suggesting the vastness of Fuji. The skill with which the Zen artist terminates his varied broad lines of flying white suggests his dexterity in controlling the seemingly spontaneous rapidly moving brush.

The use of brushstrokes to create light, medium and dark grey or black compositions in a wide range of contrasting shades of light and dark is further evidence of the Zen master's capability with brush and ink. Wet washy greys are used to create recognizable forms such as a dancer's costume in Shunsō's *Noh Dancer* (fig. IX). These broad, overlapping horizontal and vertical strokes of varying light-to-medium grey gradations depict a frozen moment in the dancer's movement. Implied by minimal dark accents suggesting

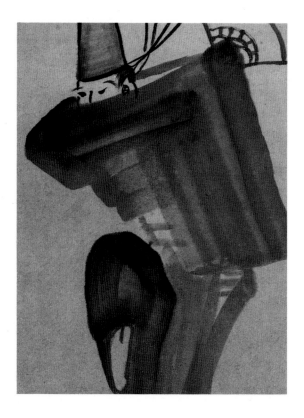

figure IX.
Washed grey brushstrokes.
*Noh Dancer.*
Shunsō, 1750-1839.
(detail, cat. no. 40)

36

the motion of his underlying bent elbows and raised knees, these tonal gradations accentuate the costume enveloping the dancer. His tight belt is suggested by exceedingly light grey tones drawn in contrast to the darker ones which highlight the costume. In keeping with the spirit of Zen art there is little delineation of the dancer's underlying anatomy. The only black lines in the composition outline the dancer's hat and facial features.

Grey washes of middle tone range describe Reigen's *Mt. Fuji* (cat. no. 54) in three simple strokes, complemented by an eggplant and a leaf. The image shows no major contrasting gradations of black or grey ink. This fairly monochrome tonality contrasts markedly with Suiō's *Zen Landscape* (cat. no. 50) where multiple, dark grey to black, circular, vertical and horizontal applications of ink denote trees and rocks, overlying lighter grey mountain peaks. The combination of non-uniform, irregular, and varied shapes creates an unusual landscape.

Achieving extraordinary tonality, Hakuin's work exemplifies an entire range of ink usage from the lightest greys to the deepest blacks. *Blind Men on a Log Bridge* (cat. no. 46) is created with a wide range of greys and blacks. The bridge of muted grey wash is visually balanced by the grey wash of the mountains, whereas the dark tones of the caricature-like blind men identify them as the subject. Hakuin's ability to depict imagery through gradations of ink is further demonstrated in the central character of his *Virtue* (cat. no. 61), composed of varying shades of thick strokes ranging from bold black to dark grey. Examination of the painting reveals a vast range of light and dark nuances confined to a deep dark palette. A textured ink splotch is prominent on top of the virtue character. This interesting effect, unique to the work of the Zen monk, results from his use of left-over, partially dry, congealed ink.

Zen monks worked within the confines of their philosophy. Spartan by discipline, with a disdain for waste, they used supplies which were given to them, in contrast to professional calligraphers who purchased and employed only the best-quality ink. For a Zen artist, painting represents the mind; the spirit of the creator rather than the quality of the materials was important. A Zen master never discarded the unused wet ink remaining at the conclusion of a calligraphy or painting session; rather he would frugally preserve it as a resource for future use. The professional calligrapher, in contrast, would discard it and start again with fresh ink. This is an example of a philosophical restraint which created an aesthetic opportunity for the Zenga master.

The artistic strength of Zen painting can be evaluated within the context of art in general. The final works of a master are generally considered to be the best because they represent a more fully developed spirit; old age provided the benefit of experience and insight. Hakuin's *Always Remember Kannon* (cat. no. 62) was done at age eighty-four, in the last year of his life. The strength of this

work, completed from top to bottom in one vigorous breath and deliberate brushstroke, required tremendous energy of body and mind. At the time when his physical prowess was greatly diminished, his spiritual strength was at its peak and provided him sustenance to complete the task.

Zen artists were committed to the study and transmission of Zen, not to art. It is the modern viewer, particularly in the West, who tends to respond to this one-dimensional aesthetic aspect of Zenga. Zen masters never considered their work as objects to display solely in the interest of art. This is best expressed by the Zen master Sengai:

> *"My play with brush and ink*
> *is not calligraphy nor painting;*
> *yet unknowingly people mistakenly think:*
> *this is calligraphy, this is painting."*
>
> translated by John Stevens

## CARE OF PAINTINGS

Zen paintings were executed with deep spiritual commitment and disciplined experience. Zen art contains the essence of the master, and Zen practitioners lovingly preserved their teachers' brush-work. The condition and longevity of these works were considered in each aspect of their mounting, handling, storage and display. This is the custom and tradition with all Japanese painting.

Two-dimensional Japanese artworks can be presented in a number of formats: hanging scrolls, hand scrolls, album leaves, fan paintings, folding screens, and sliding or stationary panels. Most Zenga are hanging scrolls (cat. nos. 1-66, 69 & 70) and less frequently screens (cat. nos. 67 & 68). The scrolls could be placed in the *tokonoma* (alcove) in a house or temple room for private viewing and meditation (fig. XI).

The mounting of paintings in different formats is an historically important and respected art form in Japan, dating back to the eighth century. Just as monks studied Zen under the tutelage of masters, so students of mounting were apprenticed to master craftsmen for a decade before being considered qualified mounters.

Typical Zenga mountings echo Zen philosophy in their austere, simple use of unadorned paper materials. The feeling of an original Zen mounting becomes an integral part of the art work, designed to enhance it rather than to emerge as a notable element on its own. Often mountings are made of inexpensive materials available to the monk or student at the time of the work's creation. Although spartan, original-style Zen mountings may vary from a thin marbleized paper in deep-blue with beige-like swirls, as surrounds Kogan's *Daruma on a Rush Leaf*, (cat. no. 21) to a simple

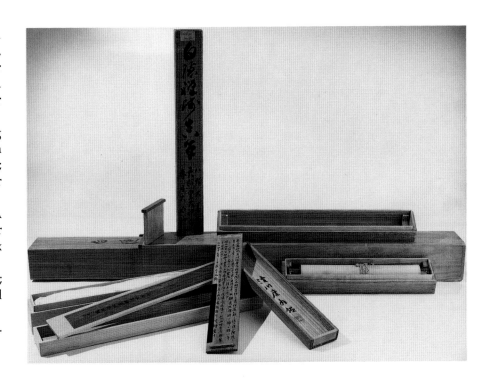

beige paper background similar in color and quality to that on which Tesshū's *Zen Calligraphy* (fig. IV, p.17) is brushed.

Each painting has a mounting style which was originally considered most appropriate. Whereas basic, frugal mountings suit the goals and imagery of an Edo Period Zen artist, colorful decorative Rimpa paintings of the same period were originally mounted on bright silk-brocade fabrics in concert with the elegant, highly decorative qualities of the artworks. As Zen paintings became considered more precious and valued by their owners in the last two generations, some chose to remount the pieces in more elaborate gold brocade and silk, while others continued to select simple papers in the original style.

Scroll mountings are designed to both enhance the aesthetics of the artwork and provide protection of the painting. They consist of several elements: paper backings adhered to the artwork, textiles or paper which surround and frame the painting and, for hanging, a wooden rod with ivory or lacquered wood knobs around which the painting can also be conveniently rolled for storage. In this regard, the Japanese scroll mounting made of paper and fabric differs from the western painting frame often made of wood or metal, in that it is less rigid and more flexible for easy movement and storage. Yet because of the time-consuming and delicate process, remounting is usually done only when necessary, in contrast to the western frame which can be easily changed. An expert mounting can last two hundred years or more depending upon the condition and care of the object.

Japanese paintings are usually shown for only short amounts of time, a few days to a few weeks, in honor of special occasions or seasons. When not exhibited, they are conveniently rolled and

figure XI.
The late rōshi of Ryūtaku-ji seated in front of an alcove with a painting by Tōrei, *Buddha Descending the Mountains Following His Enlightenment.*

Photograph by Kurt A. Gitter

placed in an individual *hako* (box) for storage. In the damp climate of Japan, these *hako* (fig. X) were essential for the preservation of scrolls which, left unprotected, might be ruined by mold and insect damage. In the past each box was typically made of *kiri* (paulownia) wood, and was individually handcrafted by special artisans to specifically fit the painting. Often, specially valued scrolls like Hakuin's *Giant Daruma* were contained in double boxes for extra protection.

The tradition of box storage created an environment whereby box inscriptions and seals by previous owners, famous scholars, tea masters, Buddhist priests and other outstanding figures were prized in themselves, and served as historical confirmation about the artist. For example, when the original box for Fūgai's *Hotei Pointing at the Moon* was beyond repair, the scroll was refitted with a new *hako*, but the box maker carefully preserved the old lid, inscribed in excellent seal script, by inlaying it into the new top.

The interior of the lid sometimes contains an elaborate inscription giving details on the artist, comments on the painting and similar information. During hard times (or if the abbot was dissolute), temple treasures were sometimes sold off after the name of the temple was effaced from the box's inscriptions as shown in the lid for Shunsō's *Half Body Daruma.*

40

Boxes inscribed subsequent to the death of the artist also confirm the authenticity of the enclosed work. The box for Sengai's *Three Gods of Good Fortune* is inscribed and signed by Awakawa Yasuichi, a modern connoisseur and writer about Zen art who "guaranteed" that the scroll was genuine. The box for Hakuin's *Three Shintō Deities* bears the inscription of a recent abbot of Shōin-ji, Hakuin's temple, who guaranteed the authenticity of the work. Such guarantees usually were based on careful scrutiny and comparison of the seals on the scroll with the master's seals preserved by the temple and accessible to the abbot for study.

The individual care for the preservation of Zen painting continues today in the homes of collectors, in museums and Zen temples where works are often contemplated, as described in the final section of the exhibition. A recent visit by this writer to Hakuin's temple Ryūtaku-ji confirmed that Zenga is still treasured and preserved. This personal experience provided a much-cherished human perspective and response to Zen painting. Daizaburō Tanaka, a major collector of Hakuin paintings arranged for a special audience with the *rōshi* (abbot). The *rōshi* sat on a *tatami* mat adjacent to the *tokonoma* (alcove) in which a painting by Tōrei, *Buddha Descending from the Mountain Following His Enlightenment* (fig. XI), was hanging. Through opened *fusuma* (sliding doors), the beauty of the autumn red maples and the wonderful sound of garden waterfalls permeated one's senses.

The abbot served cakes, tangerines and *saké*, and presented a calligraphy by his own hand. The setting was timeless: the traditional architecture of the room and temple grounds, the calming sounds of visible nature and the *rōshi's* crossed legged seated

Photograph by Kurt A. Gitter.

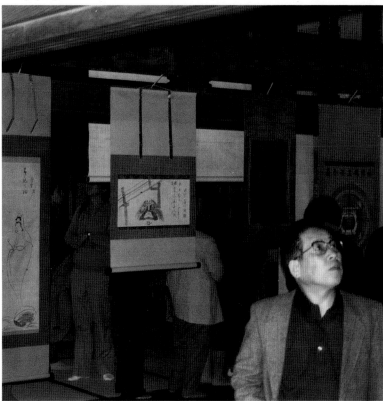

figure XII.
A view of *mushi boshi* at
Ryūtaku-ji Temple.

position. The small Seiko clock, the only modern element in the room, confirmed this observation.

It was *mushi boshi*, the day each year when the temple's entire holdings of painting and calligraphy are displayed for public viewing while they are simultaneously opened to air. This tradition, dating back hundreds of years, deters insect infestation of the scrolls and their storage boxes. November 23 is the annual observance at Ryūtaku-ji, selected no doubt for the crisp, dry autumn air quality.

The paintings were displayed throughout the temple, side by side, in no particular historical order, attached to beams, covering all available wall space and closed *fusuma* (fig. XII). This is in direct opposition to the typical Japanese-style of displaying only one object at a time.

The majority of the paintings were Zenga painted by Hakuin or his followers who had lived at this temple or had brought gifts during pilgrimages. The storage boxes were neatly placed in front of each work on a broad strip of red felt cloth which served as a division between artwork and viewer. The visitors, mostly local parishioners, respected the necessary distance one needed to keep from the paintings. Unlike museum displays, there were no plexiglass covers or wooden barriers, and no labels or explanations. The works were there for one-to-one communication.

*Mushi boshi* is a special experience reflecting both a religious and artistic reverence for the fragility of the temple's art treasures. Amidst the large crowd of engaged viewers a young monk sat deeply centered in *zazen* (meditation) suggesting simultaneously past, present and future Zen experiences. For this writer, in this environment, the aesthetic and spiritual magic of Zenga was clear.

# A ZEN KŌAN

A monk asked his master to express Zen on paper so that he would have something tangible to study. At first the master refused saying, *"Since it is right in front of your face why should I try to capture it with brush and ink?"* Still the monk continued to plead with the master for something concrete. The master drew a circle on a piece of paper and added this inscription: *"Thinking about this and understanding it is second best; not thinking about it and understanding it is third best."* The master did not say what is first best.

# WORKS IN THE EXHIBITION

1 a & b Ōbaku SOKUHI (1616-1671), *Dragon and Tiger*

## DARUMA: THE GRAND PATRIARCH OF ZEN

 2 HAKUIN Ekaku (1685-1769), *Giant Daruma*
 3 FŪGAI Ekun (1568-1654), *Half Body Daruma*
 4 FŪGAI Ekun (1568-1654), *Half Body Daruma*
 5 HAKUIN Ekaku (1685-1769), *Half Body Daruma*
 6 REIGEN Etō (1721-1785), *Half Body Daruma*
 7 SHUNSŌ Jōshu (1750-1839), *Half Body Daruma*
 8 TAKUJŪ Kosen (1760-1833), *Half Body Daruma*, 1832
 9 KOKAI Jikō (1800-1874), *Half Body Daruma*
10 HŌJŪ Zenbyō (1802-1872), *Half Body Daruma*
11 Nakahara NANTEMBŌ (1839-1925), *Half Body Daruma*, 1917
12 SANSHŌKEN Yūzen Gentatsu (1841-1917), *Half Body Daruma*
13 Matsubara BANRYŪ (1848-1935), *Half Body Daruma*
14 HAKUIN Ekaku (1685-1769), *Side View Daruma*
15 SUIŌ Genrō (1716-1789), *Side View Daruma*
16 Ashikaga SHIZAN (1859-1959), *Side View Daruma*
17 Deguchi ŌNISABURŌ (1871-1948), *Side View Daruma*
18 DAISHIN Gitō (1656-1730), *Wall Gazing Daruma*
19 JIUN Onkō (1718-1804), *Wall Gazing Daruma*
20 Nakahara NANTEMBŌ (1839-1925), *Wall Gazing Daruma*, 1909
21 KŌGAN Gengei (1747-1821), *Daruma on a Rush Leaf*
22 FŪGAI Ekun (1568-1654), *Daruma on a Rush Leaf*
23 Nakahara NANTEMBŌ (1839-1925), *Snow Daruma*, 1921

## ZEN HEROES

24 FŪGAI Ekun (1568-1654), *Hotei Pointing at the Moon*
25 HAKUIN Ekaku (1685-1769), *Hotei's "Fuki"*
26 HAKUIN Ekaku (1685-1769), *Hotei's Bag*
27 SENGAI Gibon (1750-1838), *Hotei Waking from a Nap*
28 Zuikō CHINGYŪ (1743-1822), *Kanzan and Jittoku*, 1818
29 GŌCHŌ Kankai (1749-1835), *Kanzan and Jittoku*, 1834
30 a & b KŌGAN Gengei (1747-1821), *Kanzan and Jittoku*
31 a & b SHUNSŌ Jōshu (1750-1839), *Kanzan and Jittoku*
32 a & b GAKO Tangen Chiben (1737-1805), *Kanzan and Jittoku*
33 REIGEN Etō (1721-1785), *Kannon, Goddess of Compassion*
34 KŌGAN Gengei (1747-1821), *Arhats, Buddhist Saints of India and China*
35 SENGAI Gibon (1750-1838), *Lao-T'zu Riding on an Ox*
36 SUIŌ Genrō (1716-1789), *The Chinese Patriarch Rinzai*

37  SOZAN Genkyō (1799-1868), *The Japanese Patriarch Daitō Kokushi*
38  HAKUIN Ekaku (1685-1769), *Tenjin*
39  DAISHIN Gitō (1656-1730), *Hitomaro*
40  SHUNSŌ Jōshu (1750-1839), *Noh Dancer*

## ZEN TEACHINGS

41  HAKUIN Ekaku (1685-1769), *Monk on Pilgrimage*
42  Nakahara NANTEMBŌ (1839-1925), *Zen Staff*, 1923
43  KŌGAN Gengei (1747-1821), *Procession of Monks*
44  TŌREI Enji (1721-1792), *Zen Circle of Enlightenment*
45  TSU'Ō Sōtetsu (1801-1854), *Enlightenment Certificate*
46  HAKUIN Ekaku (1685-1769), *Blind Men on a Log Bridge*
47  HAKUIN Ekaku (1685-1769), *Bonseki*
48  HAKUIN Ekaku (1685-1769), *Treasure Boat*
49  SENGAI Gibon (1750-1838), *Three Gods of Good Fortune*
50  SUIŌ Genrō (1716-1789), *Zen Landscape*
51  SENGAI Gibon (1750-1838), *Zen Landscape*
52  REIGEN Etō (1721-1785), *Shrine of Tenjin*
53  CHŪHŌ Sōu (1759-1838), *Mt. Fuji*
54  REIGEN Etō (1721-1785), *Mt. Fuji*
55  SHUNSŌ Jōshu (1750-1839), *Mt. Fuji*,
56  Ōtagaki RENGETSU (1791-1875), *Drying Persimmons*, 1868
57  HAKUIN Ekaku (1685-1769), *Monkey*

## ZEN CALLIGRAPHY

58  HAKUIN Ekaku (1685-1769), *Two Line Calligraphy*
59  HAKUIN Ekaku (1685-1769), *Three Shintō Deities*
60  HAKUIN Ekaku (1685-1769), *Death Kōan*
61  HAKUIN Ekaku (1685-1769), *Virtue*
62  HAKUIN Ekaku (1685-1769), *Always Remember Kannon*
63  TŌREI Enji (1721-1792), *Calligraphic Talisman*
64  JIUN Onkō (1718-1804), *Two Line Calligraphy*
65  a & b Ōtagaki RENGETSU (1791-1875), *Tanzaku Poems*, 1870
66  Yamaoka TESSHŪ (1836-1888), *Dragon*
67  a & b Yamaoka TESSHŪ (1836-1888), *Pair of Six-Panel Screens*
68  a & b Nakahara NANTEMBŌ (1839-1925), *Pair of Two-Panel Screens*, 1923

## ZENGA: THE CONTEMPLATIVE ART

69  Nakahara NANTEMBŌ (1839-1925), *Zen Circle*, 1923
70  REIGEN Etō (1721-1785), *Kōan*

*Instead of hanging up fancy pictures in your homes, display paintings of Zen teachings in you favorite place. Honor that tradition with respect and you will be free from all distress.*

Hakuin Ekaku

1 a & b Ōbaku SOKUHI, 1616-1671
*Dragon and Tiger*
sumi on paper
44 1/2 x 20 1/8 inches each (113.0 x 51.1cm)
The Gitter Collection

Sokuhi, a Chinese emigre monk of the Ōbaku Zen Sect, portrays here the dragon and the tiger in both pictorial (concrete) and calligraphic (abstract) forms. The dragon, symbolic of spiritual power and enlightened wisdom, commands the heavens while the tiger, the embodiment of physical strength and courageous living, rules the earth. In Zen art, the pairing of the dragon and the tiger—representing the two great forces of the universe—signifies the harmonization of the spiritual and material. Sokuhi's delightful work is a splendid example of Zen brushwork—bold, dynamic, vivid, profound and yet enlivened by subtle playfulness. These two paintings serve as a dramatic introduction to the exhibition.

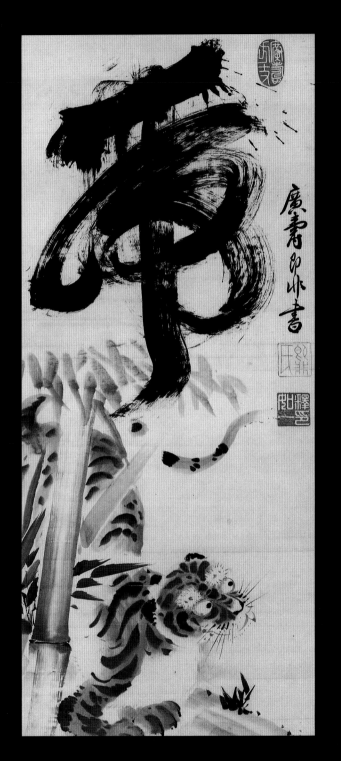

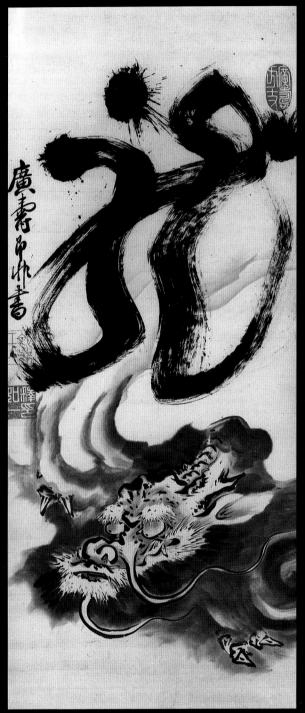

# DARUMA, THE GRAND PATRIARCH OF ZEN

The foremost symbol of Zen is its first patriarch Daruma (Sanskrit, Bodhidharma), the legendary meditation master who traveled from India to China in the sixth century to overturn the top-heavy superstructure of doctrinal Buddhism that was being erected in the Middle Kingdom. Daruma's famous encounter with the Emperor of China went like this:

> *"I've constructed dozens of Buddhist temples, supported hundreds of monks and nuns, and sponsored countless religious ceremonies,"* the proud emperor informed Daruma. *"How great is my merit?"*
> *"No merit at all,"* Daruma replied bluntly.
> *"Tell me then,"* the emperor wanted to know, *"What is the first principle of Buddhism?"*
> *"Vast emptiness, nothing holy!"* Daruma shot back.
> *"Who are you?"* the thoroughly perplexed emperor demanded.
> *"I don't know!"* Daruma announced, departing as suddenly as he had appeared.

Daruma's teaching is often summarized as, *"Enlightenment is not found in books or in the performance of empty rites; Zen is none other than your own mind so look within and wake up!"* In Zenga, the artist is not painting Daruma as an historical figure (or even a saint) but as a symbol of penetrating insight, self-reliance, ceaseless diligence, and the rejection of all externals. Furthermore, in order to bring the image of Daruma alive with brush and ink, the artist must become Daruma. Thus, a Daruma painting is a spiritual self-portrait, based on the individual experience of each Zen master.

2  HAKUIN Ekaku, 1685-1769
*Giant Daruma*
sumi on paper
51 1/2 x 21 3/4 inches (130.8 x 55.2 cm)
The Gitter Collection

This massive image by Japan's great master  Hakuin epitomizes Zen art—
unadorned, direct, substantial and bristling with spiritual force.  Free of
embellishments and elaboration, the painting presents Buddhism in its most
concentrated form.  In the inscription on the painting, Hakuin challenges us:

> *(Zen) is a direct pointing to the human heart;*
> *See into your nature and become Buddha!*

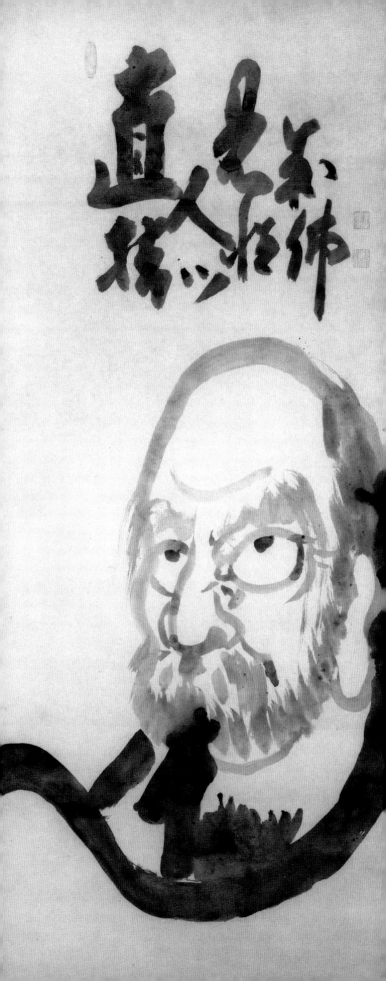

# HALF BODY DARUMA

As an embodiment of universal truth—*"unable to be contained by heaven and earth"*—Zen artists generally refrained from depicting Daruma's full form.  Also, by revealing only the upper half of Daruma's body, Zen artists challenged the viewer to look beyond the surface in order to grasp the Patriarch's essence.  Although seemingly hidden from view, Daruma's core—the Buddha-mind—can be discerned if one contemplates the painting as an organic whole rather than trying to analyze it from historical, aesthetic, or philosophical perspectives.

In half body Darumas, the face and head are brushed ·first (the heavy beard and exotic earring denoting Daruma's Indian origins), then the robe, and finally the eyes are dotted in to animate the image.  Indeed, the eyes are Daruma's most prominent feature, for *"One who is wide awake has no fear or doubt."*  Regarding the length of time it takes to compose a Daruma painting, Hakuin said in reply to that question, *"Ten minutes—and eighty years."*

3  FŪGAI Ekun, 1568-1654
*Half Body Daruma*
sumi on paper
25 x 12 inches  (63.5 x 30.5 cm)
The Gitter Collection

Free-spirited Fūgai, who spent most of his days  on the road or hiding out in caves, actually lived much like Daruma.  Fūgai exchanged his paintings for provisions from the local villagers and his artworks were treasured for generations by country folk prior to being "discovered" by scholars and collectors.  Firmly constructed and finely textured, the brushstrokes of Fūgai's Daruma are clear and luminous.  Still radiant after four centuries, this Daruma remains a living presence.  (Until recently, the value of Zenga was not recognized by many dealers, and on this particular piece, Fūgai's original seal—on the right above Daruma's head—has been effaced and a fake "Nobutada" seal added in a foolish attempt to increase the value of the painting.)

4 FŪGAI Ekun, 1568-1654
*Half Body Daruma*
sumi on paper
19 x 13 inches  (48.3 x 33.0 cm)
The Gitter Collection

*A single hawk soars through the sky,*
*Sparrows cower but there is no escape!*
*Swooping down as swiftly as a falling stone,*
*Talons bared, it launches an attack in all directions!*

Blackened by several centuries of soot accumulated from the hearth of the
farm house in which it once hung, this Daruma is more roughhewn than
Fūgai's other versions, and the eyes more penetrating than usual.  The
dynamic imagery of the inscription well conveys the intention of a Zen
master to shake lethargic human beings out of their complacency.

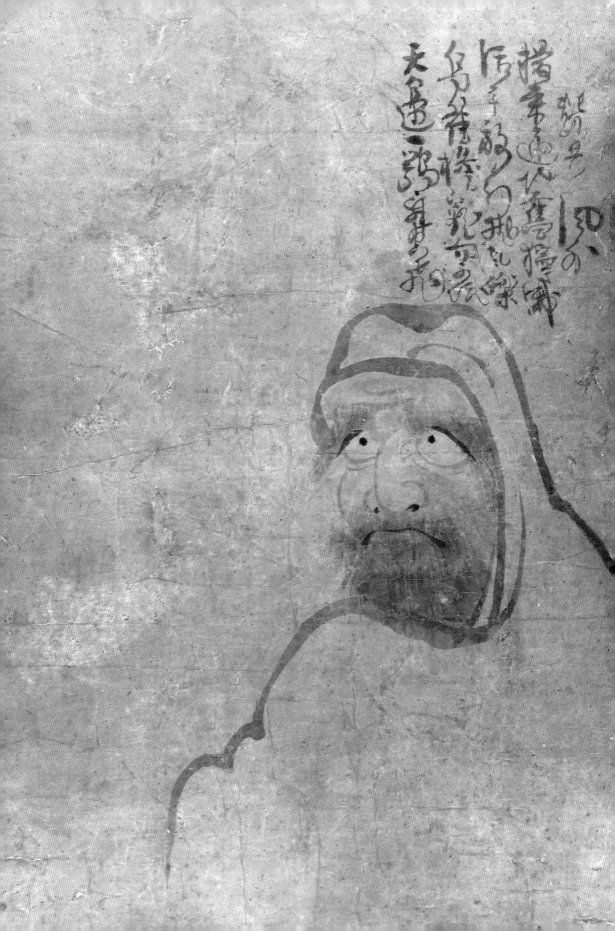

5 HAKUIN Ekaku, 1685-1769
*Half Body Daruma*
sumi on paper
32 1/4 x 10 1/4 inches  (81.9 x 26.0 cm)
The Gitter Collection

> *Bamboo rustles in the cool freshness,*
> *Shattering the golden shadows of the moon.*

Typical of most masters, Hakuin did not start painting until he had been well seasoned by Zen training (in his case at age sixty).  This Daruma, likely dating from Hakuin's mid-seventies, has a softer, more reflective cast than his Great Darumas which can be overwhelming.  The brushstrokes are bright, rich and vibrant.  The Patriarch's robe is skillfully formed by the character for "heart" and the inscription, too, identifies Daruma with the spirit of things.  When we are one with the universe, all of nature becomes our meditation hall.

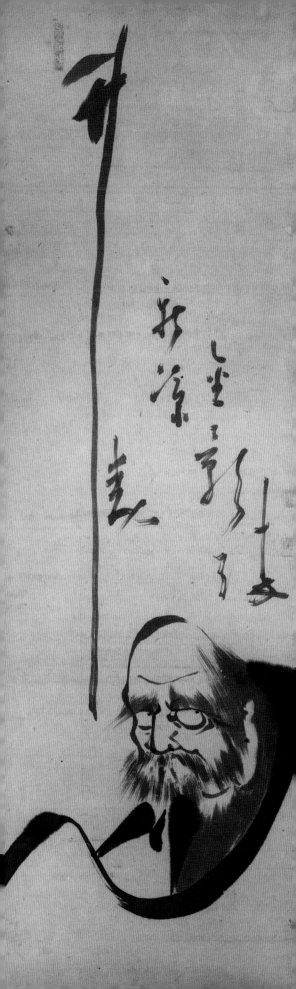

6  REIGEN Etō, 1721-1785
*Half Body Daruma*
sumi on paper
26 1/2 x 11 inches  (67.3 x 27.9 cm)
New Orleans Museum of Art:
Gift of Dr. and Mrs. Kurt A. Gitter, 82.146

*Son of an Indian prince,*
*Disciple of a meditation master from Central Asia*
*(Daruma has ended up here...)*

Not much is known about Reigen, who once lived as a hermit for more than
a decade.  Reigen was a disciple of Hakuin, and even though his Daruma is
based on the style learned from his master, it is hardly a copy—Reigen's
unique vision of Daruma is clearly evident.  The thick, black brushstrokes of
the Patriarch's robe are particularly impressive and the simple paper
mounting suits the painting perfectly.  The inscription alludes to the
transmission of Zen from East to West.  Daruma was born in India, studied
Zen in Central Asia, carried it to China, and his descendants eventually
transmitted his teachings to Japan.  From Japan, this painting has been
brought to the West to proclaim Daruma's message in modern times.

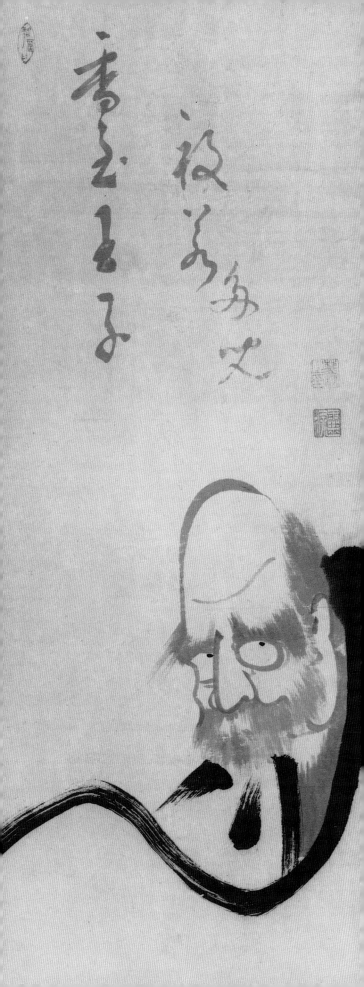

7 SHUNSŌ Jōshu, 1750-1839
*Half Body Daruma*
sumi on paper
41 3/4 x 15 7/8 inches  (106.0 x 40.3 cm)
Private Collection

Shunsō studied under Reigen as well as several other of Hakuin's direct disciples.  His straightforward Daruma seems to have a slightly harder edge to it than the others, and we can sense the fierce determination of the Patriarch.  Shunsō's Daruma, with his stern eyes fixed on the viewer confronts us directly, *"Well, how about it?"*

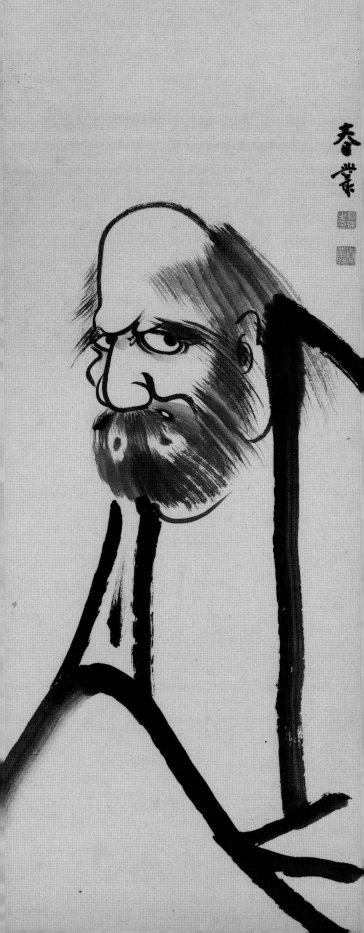

8  TAKUJŪ Kosen, 1760-1833
*Half Body Daruma*, 1832
sumi on paper
22 1/4 x 26 inches  (56.5 x 66.0 cm)
The Gitter Collection

*Externally, cut off all relationships;*
*Internally, do not stir the mind.*
*When your mind resembles a solid wall,*
*You can enter the Way (of Zen).*

Takujū, abbot of Kyoto's Myōshin-ji, was renowned as a demanding and precise Zen master, attributes reflected here in his no-nonsense portrayal of Daruma, which he created with sharp and well-defined brushstrokes, and the rather severe tone of the inscription.  Brushed the year before his death, Takujū's crusty old Daruma shows no signs of slacking off.

9  KOKAI Jikō, 1800-1874
*Half Body Daruma*
sumi on paper
52 1/2 x 24 inches  (133.4 x 61.0 cm)
The Gitter Collection

> *(Zen) is a direct pointing to the human heart;*
> *See into your nature and become Buddha.*

Kokai was the longtime head monk at Nanzen-ji in Kyoto.  The local people considered Kokai something of a miracle man, since his gentle Daruma paintings were reputed to possess the uncanny ability to calm upset or peevish children—a child placed in a room where a Kokai Daruma painting was hanging was assured of a sound sleep.  The inscription is standard, but in this case it seems more like a guarantee than a demand.

佛
見
性
の

立
拈
人
一

前
翁
後
正
海

10  HŌJŪ Zenbyō, 1802-1872
*Half Body Daruma*
sumi on paper
35 1/4 x 11 3/4 inches  (89.6 x 29.8 cm)
Private Collection

*Vast emptiness, nothing holy!*

The inscription reproduces Daruma's reply to the question, *"What is the first principle of Buddhism?"*  Zen is not a teaching set in stone; try to grasp it and it will vanish into space.  Set it up as something holy and you will lose the essence of Zen which is beyond sacred and profane.  The virtuous priest Hōjū, a disciple of Takujū, was held in high esteem by his contemporaries but works by him are, unfortunately, rare.  This Daruma is a fine example of pure Zen art, created without any sort of pretension or artifice.

11  Nakahara NANTEMBŌ, 1839-1925.
*Half Body Daruma*, 1917
sumi on paper
38 1/4 x 16 inches  (97.2 x 40.6 cm)
Private Collection

*I don't know!*

Although Nantembō, armed with a heavy wooden staff, was unrelentingly severe with his students, his charming Daruma paintings reveal a light-hearted side to his character.  Brushed with humor and a touch of self-caricature, Nantembō's Daruma appears to be shrugging his shoulders as he states, *"I don't know (…anything about Zen)."*

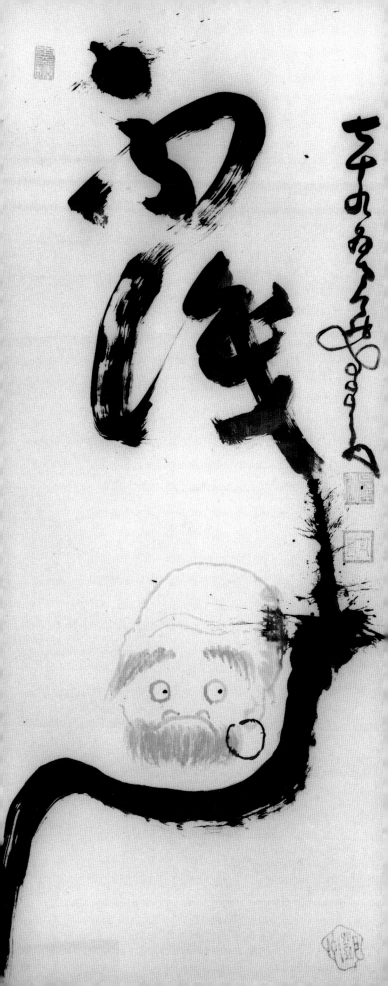

12  SANSHŌKEN Yūzen Gentatsu, 1841-1917
*Half Body Daruma*
sumi on silk
76 3/4 x 22 7/8 inches  (194.9 x 58.1 cm)
The Gitter Collection

*See into your nature*
*And become Buddha!*

Sanshōken was a big, burly man much like Daruma himself was supposed to have been.  Despite his forbidding appearance, however, Sanshōken was known for his large heartedness and good humor; his Zen sermons were entertaining as well as instructive.  Sanshōken was in fact a skilled painter, but his delightful Darumas are childlike, permeated with joy and total self-abandon.

見性
成佛
三十
牧
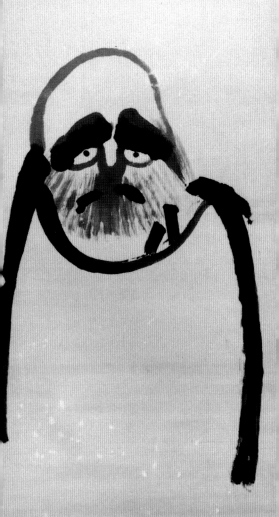

13  Matsubara BANRYŪ, 1848-1935
*Half Body Daruma*
sumi on paper
54 5/8 x 15 5/8 inches  (138.7 x 39.7 cm)
Private Collection

> *(Zen) is a direct pointing to the human heart;*
> *See into your nature and become Buddha.*

Even for a Zen master, Banryū got a late start as an artist—he did not start painting until he was in his eighties.  Banryū's brushwork is pure, unadulterated Zen art; direct, forceful, and totally unaffected.  Banryū's Daruma here is a true self-portrait, depicting a wise old patriarch gently admonishing his followers to wake up and bloom.  Interestingly, Banryū had many female disciples and he gave several of them full authority to teach Zen.

性來佛
直指人心尺

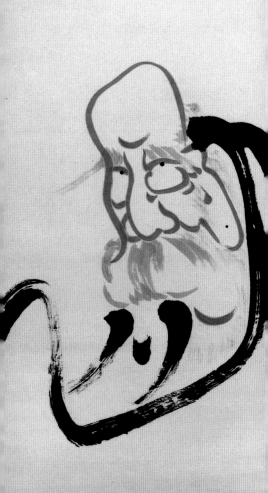

## SIDE VIEW DARUMA

Daruma is occasionally shown in profile, projecting a sense of the Patriarch's vertical extension from earth to heaven.

14  HAKUIN Ekaku, 1685-1769
*Side View Daruma*
sumi on paper
35 1/4 x 10 1/2 inches  (89.6 x 26.7 cm)
The Gitter Collection

*I've always got my eye on you!*

This was one of Hakuin's favorite inscriptions for his Daruma paintings. During the long Zen meditation sessions, drowsy practitioners are supposed to conjure up the image of Daruma and his ever-vigilant stare to help them snap out of their sleepiness.  Hakuin further suggests that Daruma is always looking at Zen students, demanding their best at all times.  Extraordinarily bright and sharp, this work dates from Hakuin's mid-sixties.

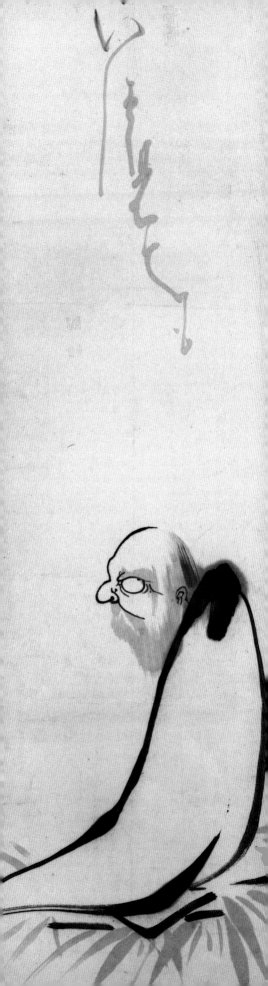

15 SUIŌ Genrō, 1716-1789
*Side View Daruma*
sumi on paper
38 x 11 1/2 inches  (96.5 x 29.2 cm)
The Gitter Collection

*See into your nature*
*And become Buddha!*

Suiō was one of Hakuin's top disciples but their characters were utterly different—Hakuin was deep and demanding while Suiō was carefree and easy going.  Suiō's Daruma certainly has an edge to it, but the lines of the patriarch's robe and the brushstrokes of the calligraphy are extremely supple, free of the controlled tension that we sense in Hakuin's work.  Suiō excelled at painting and it is thought that he actually served as Hakuin's art teacher for a time.

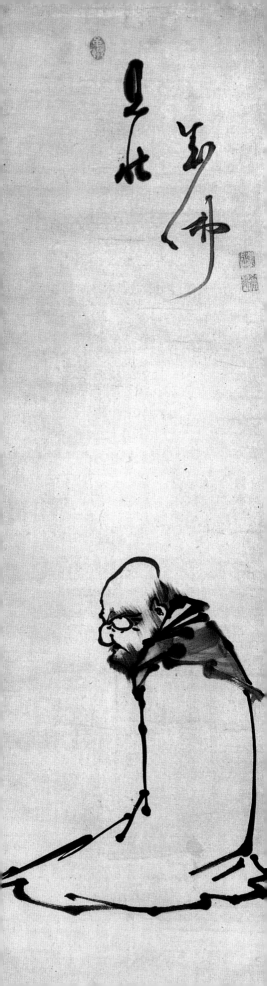

16  Ashikaga SHIZAN, 1859-1959
*Side View Daruma*
sumi on paper
58 x 31 inches  (147.3 x 78.7 cm)
Private Collection

*Vast emptiness*
*Nothing holy!*

Shizan was an activist Zen master who established orphanages as well as meditation halls.  During the latter part of his long life, Shizan never handled money even when he traveled, relying instead on the natural charity of human beings to get by.  Shizan produced Zen art until his death at age one hundred.

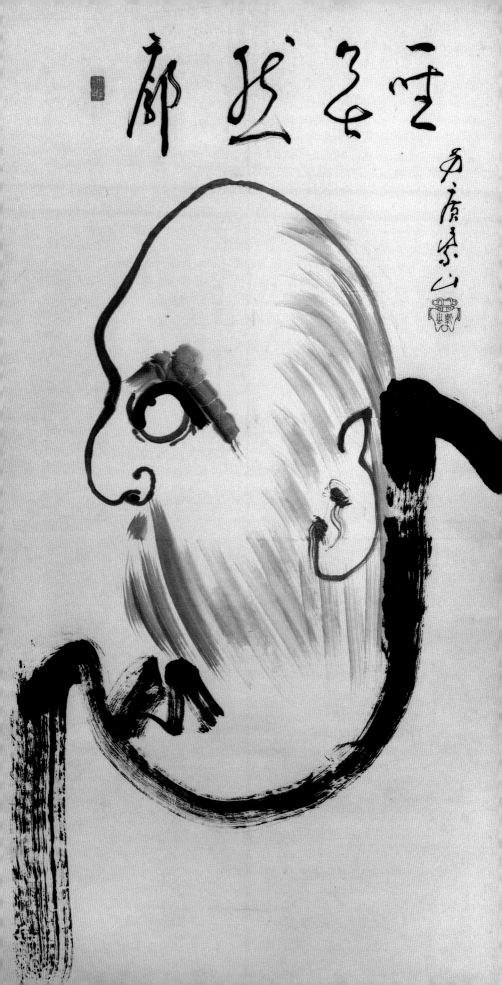

17 Deguchi ŌNISABURŌ, 1871-1948
*Side View Daruma*
sumi on paper
37 x 11 inches  (94 x 27.9 cm)
Private Collection

Here is a fascinating interpretation of Daruma by a Shintō shaman.  This Daruma has a mysterious, otherworldly aura to it—notice especially the eye—and projects a different sort of energy than the other examples in the exhibition.  Despite a totally different mind-set, Ōnisaburō is still able to share the Zen vision.  In addition to being one of the most significant (and controversial) religious leaders of modern times, Ōnisaburō was an artistic genius, a talented potter as well as an outstanding painter and calligrapher.

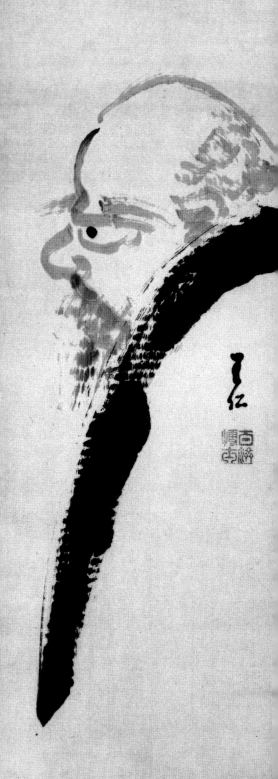

## WALL GAZING DARUMA

In this manifestation, Daruma is shown from the back, sitting facing the wall in the cave where he contemplated the Absolute for nine straight years. "Wall" stands for a barrier which prevents the world's dust and corruption from entering and for a shield which guards against all delusive ideas and sensuous images; "gazing" means to confront oneself in unrelenting meditation, relying only on one's inner resources.

18  DAISHIN Gitō, 1656-1730
*Wall Gazing Daruma*
sumi on paper
25 x 10 1/4 inches  (63.5 x 26.0 cm)
New Orleans Museum of Art: Anonymous Gift, 79.220

> *Daruma departed from South India*
> *And came east to China;*
> *The Kingdoms of Liang and Wei could not*
> *    comprehend him,*
> *So here he sits in solitary splendor*
> *    contemplating the wall.*

Unlike many of the aristocratic Daitoku-ji abbots, who tended to be Zen dilettantes, Daishin was an authentic master with a wide following among all manner of people.  His resolute Daruma sits calmly and solidly.

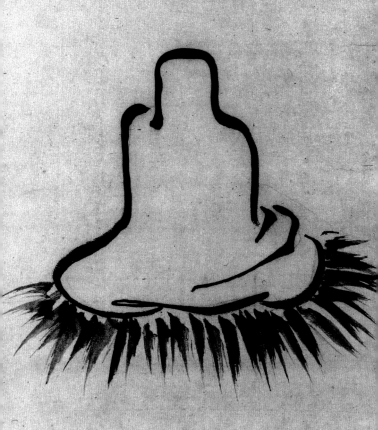

離南天竺　來東震旦
梁魏不容　擔自壁觀

古心統珎題

19  JIUN Onkō, 1718-1804
*Wall Gazing Daruma*
sumi on silk
36 3/4 x 14 3/4 inches  (93.4 x 37.5 cm)
The Gitter Collection

*Take a good look and discover*
*That one's true nature*
*Is an inexhaustible treasure*
*Transmitted from generation*
*To generation.*

Although a monk of the esoteric Shingon Sect, Jiun is considered one of the great Zen artists.  This abbreviated Daruma is particularly luminous, radiating wisdom and warmth.

見ても〳〵きまた

信いて弟代をたゝぬ

をゝゝ面目至小袴

葛塚山人

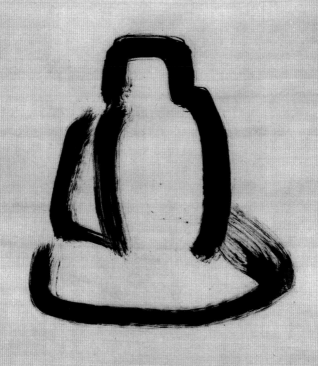

20  Nakahara NANTEMBŌ, 1839-1925
*Wall Gazing Daruma*, 1909
sumi on paper
52 1/2 x 12 1/2 inches  (133.4 x 31.7 cm)
Private Collection

> *The form of our Grand Patriarch*
> *Facing the Wall-*
> *Or is it a melon or an eggplant*
> *From around Yahata in Yamashiro?*

Nantembō jokes, *"If external appearance is all there is to Zen, then the melons and eggplants from Yahata* (where Nantembō once lived) *are sitting just as well as Daruma and taste good besides"*— a humorous reminder to Zen students to bite into the core instead of being content with just the peel.

## DARUMA ON A RUSH LEAF

Following his enigmatic dialogue with the Emperor, legend maintains that Daruma miraculously floated across the vast Yangtze River on a single rush leaf. Iconographically, the event symbolizes *"smooth sailing over turbulent waves of samsara through the power of Zen meditation."*

21  KŌGAN Gengei, 1747-1821
*Daruma on a Rush Leaf*
sumi on paper
26 3/4 x 11 1/4 inches  (68.0 x 28.5 cm)
New Orleans Museum of Art: Gift of Dr. and Mrs. Kurt A. Gitter
in honor of E. John Bullard, 82.53

> *Anyone who understands Daruma's*
> *actions can do likewise!*

Kōgan's bold rush leaf Daruma greets the viewer head on as if to say, *"Here I come!  And why not join me?"*

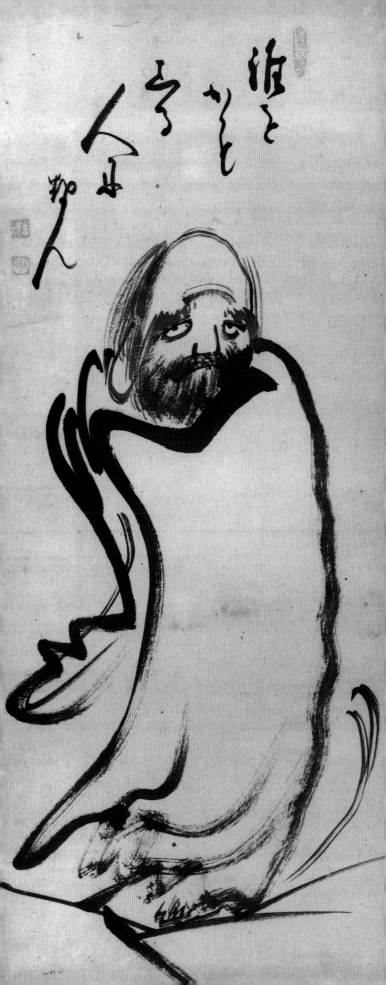

22  FŪGAI Ekun, 1568-1654
Inscribed by Tōmyō
*Daruma on a Rush Leaf*
sumi on paper
24 1/4 x 10 1/2 inches  (61.6 x 26.7 cm)
Dorothy and David Harman Collection

*Here is the symbol of our tradition,*
*The Great Master,*
*First Patriarch of China,*
*And Twenty-eighth in descent from Buddha.*

Once again we are reminded of the transmission of Zen from East to West.  In excellent condition, unlike most Fūgai works which were hung in farm houses for centuries, this was almost certainly preserved in a temple.

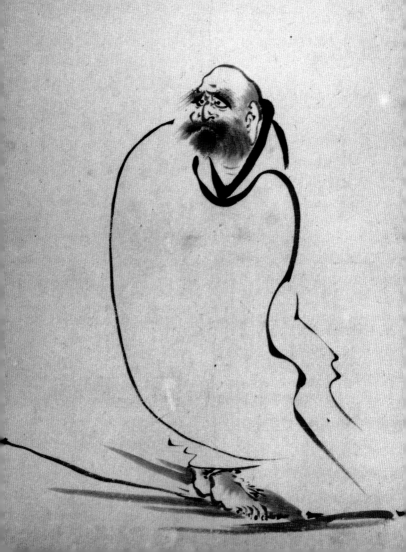

沖相應名祖明曰
土宗震旦初祖天二
十八祖 梵野法孫
東明拜書

23  Nakahara NANTEMBŌ, 1839-1925
*Snow Daruma*, 1921
sumi on paper
48 1/2 x 13 1/4 inches   (123.2 x 33.7 cm)
Private Collection

*A Daruma is made*
*of piled up snow —*
*As the days pass*
*He disappears*
*But where did he go?*

In Japanese, "snowman" is *"yuki-daruma."*  The inscription, a poem originally composed by Tesshū, means *"appreciate the form while it lasts but do not get upset when it disappears, for that is the nature of all things."*

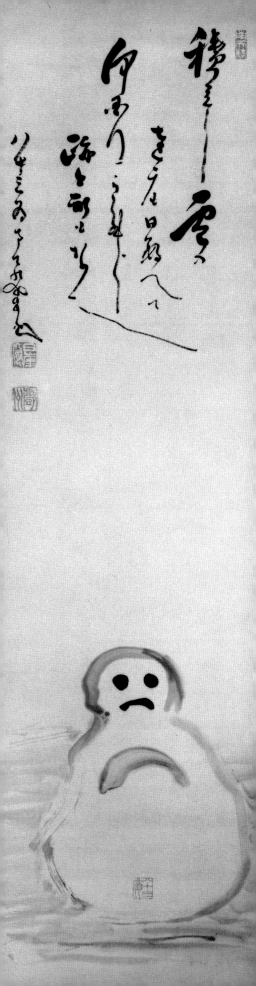

Those valiant men and women who have attained the highest levels of realization are considered "Heroes," model figures who reveal the true nature of the Way of Zen. Not surprisingly, Zen heroes tend to be down-to-earth, unsanctimonious types rather than "saints." Indeed, there is a famous Zen story regarding this trait:

> *Prior to meeting the Fourth Patriarch, the monk Gozu*
> *(Niu-tou) was so holy the birds and beasts brought him food.*
> *After attaining enlightenment under the Patriarch, the birds*
> *and beasts stopped doing so. Why?*

## HOTEI

While the stern Daruma stands for the intensity and penetrating insight of Zen practice, Hotei, the mythical Chinese saint whose pot-bellied image is found the world over, represents the freedom and joy of Zen attainment. The "ox of the mind" has been tamed and harnessed—Hotei mixes with all sorts of people, without discriminating between high and low, dispensing various treasures from his inexhaustible bag of gifts. He eats everything, sleeps when he likes, and cannot be restricted in any way.

24  FŪGAI Ekun, 1568-1654
*Hotei Pointing at the Moon*
sumi on paper
22 x 12 inches  (55.9 x 30.5 cm)
The Gitter Collection

*His life is not poor,*
*But neither is it rich.*
*Pointing to the moon,*
*Gazing at the moon,*
*This old fellow really enjoys himself.*

Happy-go-lucky, carefree Hotei points the way to the moon (enlightenment) but warns not to concentrate on the finger (the provisional teachings). In an exuberant outpouring of spirit captured in brush and ink, Fūgai has brought Hotei alive. There is not a trace of worldliness or duplicity in this painting. Notice especially the wonderful "wind line" that indicates Hotei's joyous progression along the Way—crisp and focused, it is truly a brushstroke of enlightenment.

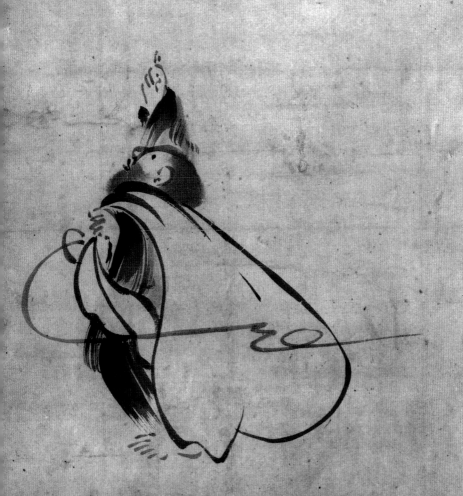

25  HAKUIN Ekaku, 1685-1769
*Hotei's "Fuki"*
sumi on paper
47 7/8 x 12 inches  (121.6 x 30.5 cm)
The Gitter Collection

*"Fuki" is also the name of a plant!*

Hakuin's Darumas may be all business, but his portrayals of Hotei are more relaxed and joyful.  Hotei here stands on top of his big bag of treasures with a gentle smile on his face.  He holds a *fuki* plant, and the inscription tells us that *fuki* (good fortune) can consist of something as simple and healthy as a tasty wild vegetable that can be picked and enjoyed by everyone, rich or poor, equally.  In other words, "the best things in life are free."  There is an ink splotch on Hotei's bag; it was accidental but instead of becoming a blot that would ruin a conventional painting here it blends in with the rest of the brushwork.

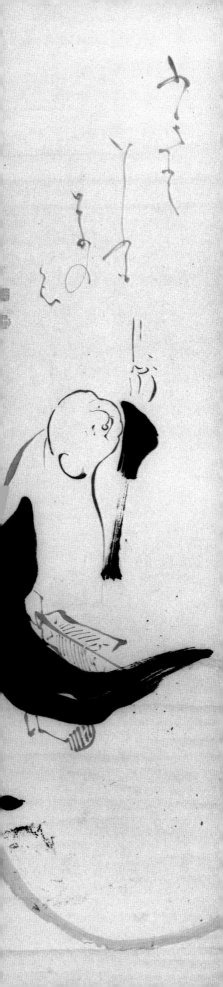

26  HAKUIN Ekaku, 1685-1769
*Hotei's Bag*
sumi on paper
14 1/8 x 21 13/16 inches  (35.9 x 55.4 cm)
New Orleans Museum of Art:  Gift of Dr. and Mrs. Kurt A. Gitter
in memory of his father, Morris Gitter, 77.19.

*While asleep, is Hotei a god,*
*A buddha, or just a stuffed bag?*

One of the principles of Zen is that "less is more," and in Zenga images are frequently reduced to the bare essentials.  Here we have only Hotei's bag, his staff and his fan.  The inscription contains a number of puns (Hakuin was very fond of such) but the central meaning is:  it depends on how you view Hotei—he can be a folk god of good fortune, a symbol of Zen freedom, or simply a roly-poly old vagabond—take your pick, for he himself sets no store by arbitrary distinctions.

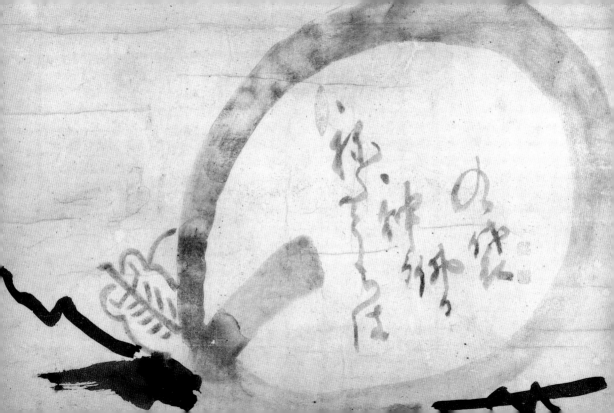

27  SENGAI Gibon, 1750-1838
*Hotei Waking from a Nap*
sumi on paper
11 5/8 x 19 1/16 inches  (29.5 x 48.4 cm)
The Gitter Collection

*What a pleasant visit with my friends in China.*

Unconstrained and full of profound good humor, Sengai said of his brushwork:

*My play with brush and ink*
*is not calligraphy and not painting;*
*Yet unknowingly people mistakenly think*
*this is calligraphy, this is painting.*

Hotei was Sengai's favorite theme—he did relatively few portraits of Daruma—and his depictions of the portly Zen hero are characterized by their wild abandon.  Here, Hotei, proud possessor of a huge belly of original emptiness, wakes up from a refreshing nap after visiting with the sages of old China in his dreams.

102

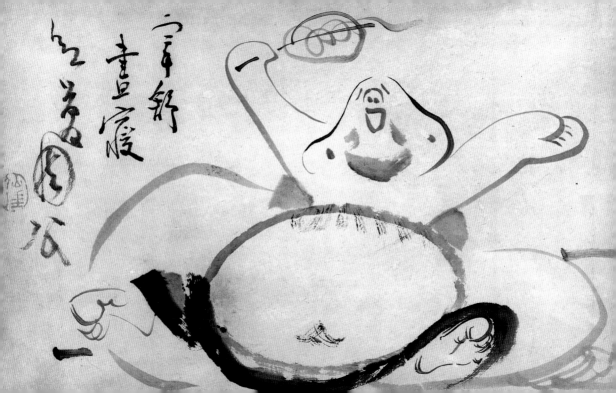

## KANZAN AND JITTOKU

Next to Daruma and Hotei, the most popular figures in Zenga are Kanzan (Han-shan) and Jittoku (Shih-te), two eccentrics who were said to have lived on a mountain in China in the eighth or ninth century. Kanzan resided in a cave and he was visited each day by Jittoku, a kitchen helper at one of the big monasteries on the mountain, who brought along table scraps for them to share. Collections of their poetry were highly valued by Zen Buddhists in Japan.

In art, the two carefree ragamuffins are typically portrayed laughing uproariously at some Zen joke, not infrequently at the expense of one of the pompous monks in the neighborhood. Neither priests nor laymen, Kanzan and Jittoku symbolize creative, enlightened living, untroubled by petty concerns, and not fettered by social conventions.

28  Zuikō CHINGYŪ, 1743-1822
Inscribed by Gōchō Kankai, 1749-1835
*Kanzan and Jittoku*, 1818
sumi on silk
50 1/2 x 22 3/4 inches  (128.3 x 57.8 cm)
New Orleans Museum of Art:  Museum Purchase, 82.96

*Both pairs of eyes look but there are no letters.*
*A single shout shakes the earth like a thousand*
  *peals of thunder.*
*Fresh breezes in the bamboo, the broom sweeps*
  *away the universe.*
*Rambling along, in the past and present,*
  *the two continuously come and go.*

Chingyū was an eccentric Sōtō Zen monk, and Gōchō, a priest of the Tendai Sect, who was famous for his mastery of esoteric science and miraculous cures. Kanzan and Jittoku, perhaps representing Chingyū and Gōchō, gaze intently upon a blank scroll containing the highest form of poetry. The inscription indicates that Kanzan and Jittoku-type characters can still be found among us.

29 GŌCHŌ Kankai, 1749-1835
*Kanzan and Jittoku*, 1834
sumi on paper
50 1/4 x 11 inches  (127.6 x 27.9 cm)
Private Collection

*Kanzan (and Jittoku)—*
*Where have they gone*
*In the sudden downpour?*

Kanzan and Jittoku are depicted here by their respective trademarks—a
scroll of poems for Kanzan, a broom for Jittoku.  Although Zen lunatics, the
pair does have the good sense to get in out of the rain!  Brushed near the end
of the artist's life, this cheerful piece projects a simple dignity and much
warmth.

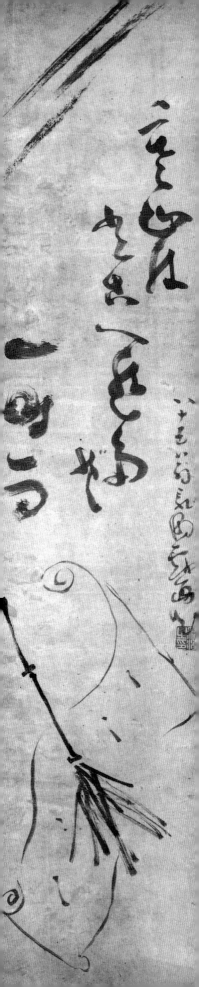

30 a & b  KŌGAN Gengei, 1747-1821
*Kanzan and Jittoku*
sumi on paper
47 x 12 1/2 inches each  (119.4 x 31.7 cm)
Private Collection

> *(Kanzan)  A gentle breeze blows through dark*
> *pines,*
> *(Jittoku)  The closer you come, the better it*
> *sounds.*

Kōgan specialized in paintings of Kanzan and Jittoku.  He was quite fond of the two Zen madmen and what they represent, lovingly brushing them in soft, radiant ink tones.  Kanzan (right) is shown with his lunch pail (a hollowed out section of bamboo).  A couplet from one of Kanzan's poems provides the inscription.

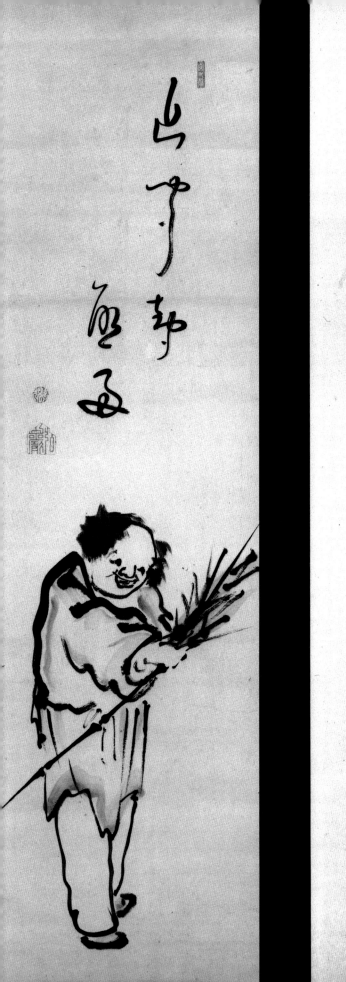
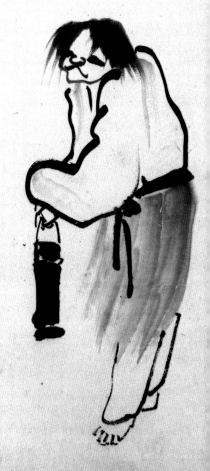

31 a & b  SHUNSŌ Jōshu, 1750-1839
Inscriptions by Gōdō Sōken, died 1835, and
Chūhō Sōu, 1759-1838
*Kanzan and Jittoku*
sumi on paper
38 3/4 x 11 1/2 inches each  (98.4 x 29.2 cm)
The Gitter Collection

A charming treatment of Kanzan and Jittoku—compare Shunsō's mood here
with that displayed in his fierce Daruma portraits (cat. no. 7).  The long
inscriptions—Gōdō on the Kanzan and Chūhō on the Jittoku—express ad-
miration of the pair and the hope that they will appear among us again.

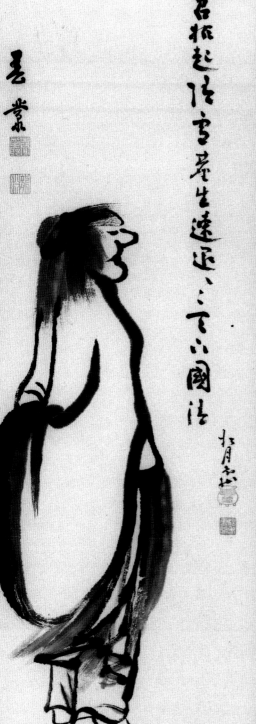

32 a & b  GAKO Tangen Chiben, 1737-1805
*Kanzan and Jittoku*
sumi on paper
36 3/4 x 10 7/8 inches each  (93.3 x 27.6 cm)
Private Collection

> *(Kanzan)  My heart is like the autumn moon—ha,*
> *ha, ha!*
> *(Jittoku)  Waves cascade over the highest*
> *mountains;*
> *Clouds of dust emerge from the bottom of a well;*
> *A stone woman gives birth to a stone child;*
> *A turtle's tail is several inches long.*

Although having the reputation of being extremely strict with himself and
his disciples, Gako was kind and considerate towards others and his Zenga
have a soft, gentle quality.  His Kanzan is singing the first line of his most
famous poem, but the artist has added a burst of laughter to it.  Jittoku, on
the other hand, rambles off a confusing set of Zen riddles.

112

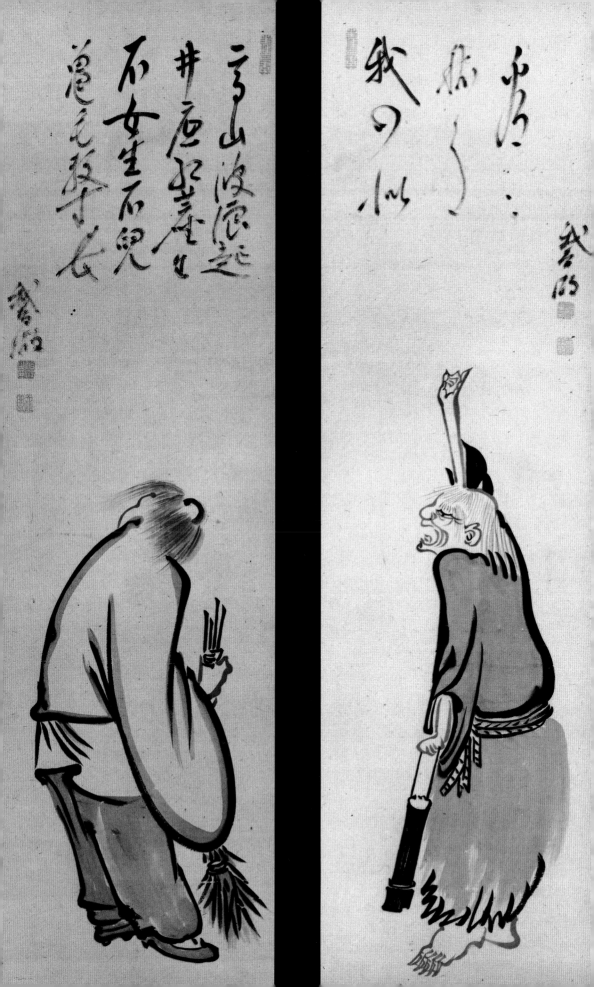

## OTHER ZEN HEROES

In addition to legendary figures such as Daruma, Hotei, Kannon and Jittoku, Zen artists depicted many other spiritual giants, historical as well as mythological, who inspire and instruct us by their examples. Since Zen is not limited to any one place or culture Zen heroes can be found everywhere.

33  REIGEN Etō, 1721-1785
*Kannon, Goddess of Compassion*
sumi on paper
37 1/8 x 11 inches  (94.3 x 27.9)
The Gitter Collection

> *In the midst of the world's corruption,*
> *A heart of pure white jade.*

The two pillars of Buddhism are insight, symbolized by Daruma, and compassion, represented by Kannon, the gentle goddess who comes to the aid of all those in distress. While portraits of Daruma are characterized by their bold masculinity, paintings of Kannon reveal the softer, more feminine side of Zen. A true Zen master is receptive to both the male and female aspects of human nature, and must be able to recreate both Daruma and Kannon in his or her art.

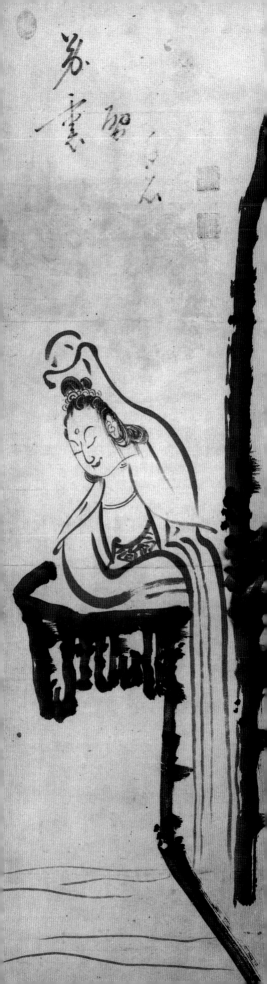

34  KŌGAN Gengei, 1747-1821
*Arhats, Buddhist Saints of India and China*
sumi on paper
40 1/2 x 10 1/8 inches  (102.9 x 25.7 cm)
The Gitter Collection

"Mind-to-mind transmission"—passing on the tradition by direct, personal encounter—is an essential facet of Zen, and the examples of the masters of the past, who maintained and transmitted the teaching, should not be forgotten.  Here, with fondness and warmth, Kōgan portrays a group of Arhats, sages from India and China.  Far from being depicted as plaster saints, the Arhats are shown to be a bunch of colorful and good-natured characters, each teaching Zen in a distinctive manner.

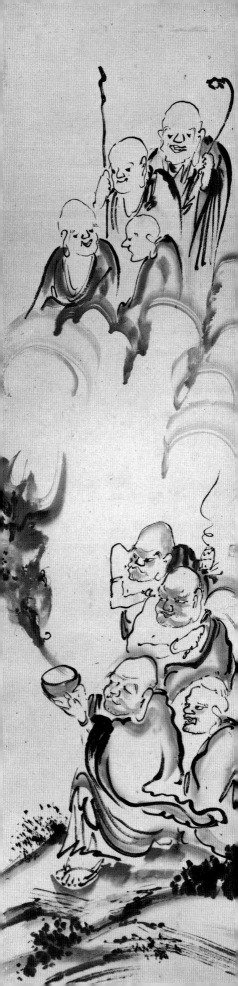

35  SENGAI Gibon, 1750-1838
*Lao-T'zu Riding on an Ox*
sumi on paper
31 x 11 inches  (78.4 x 27.9 cm)
The Gitter Collection

*This is the Way I always tread*
*But I am completely lost just the same*
*Under the hazy moon.*

Zen had much in common with Taoism, and here Sengai portrays its founder Lao-T'zu riding out of China on an ox.  The emperors of China ignored Lao-T'zu's teachings and the country fell into ruin; disgusted, Lao-T'zu mounted an ox and headed for the border.  There a guard pleaded with him to put his teachings on paper.  The result was the famous *Tao-Te-Ching*, the first line of which begins, *"The Way that can be spoken of is not the eternal Way."*  Sengai alludes to that way in his inscription, and also seems to be gently chiding Lao-T'zu for abandoning his countrymen in their time of need—it is when things are at their worst that people are most receptive to spiritual teachings.  And as Sengai further suggests, the situation will be no better anywhere else, for even the wisest sage can lose his or her "Way" in the haze.

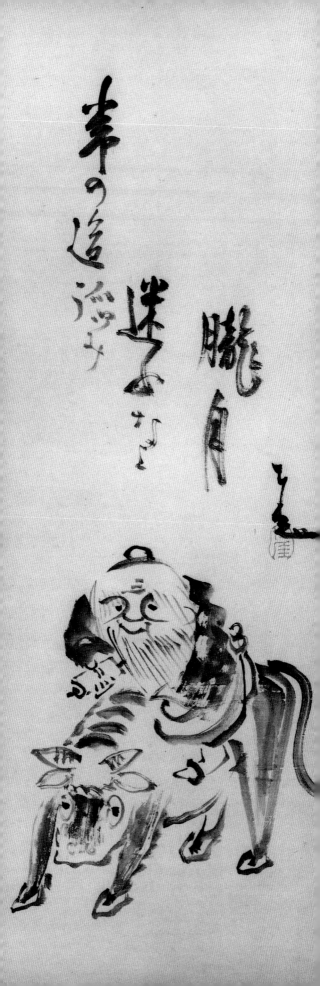

36 SUIŌ Genrō, 1716-1789
*The Chinese Patriarch Rinzai*
sumi on paper
35 1/4 x 11 1/2 inches  (89.5 x 29.2 cm)
New Orleans Museum of Art: Museum Purchase, 82.95

Rinzai (Lin-chi), the great Chinese master honored as the founder of the school of Zen which bears his name, was famed for his no-nonsense approach to Zen:  *"When hungry, eat; when tired, sleep—above all, just be human."*  Indecisive, insincere, or arrogant pupils would be sure to receive a good hard punch from Rinzai as he tried to jolt them out of their stupor.  The practical Rinzai had little use for empty ceremony and endless meditation sessions; this master's Zen practice largely consisted of planting pine trees (he is shown here with his hoe) to beautify the monastic grounds and protect the earth for future generations.

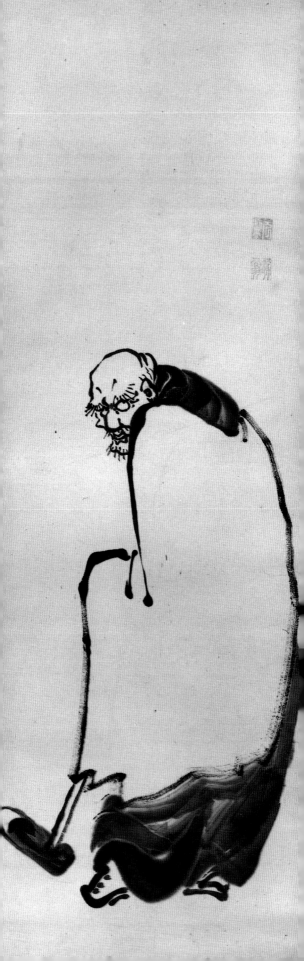

37  SOZAN Genkyō, 1799-1868
*The Japanese Patriarch Daitō Kokushi*
sumi on paper
39 1/4 x 12 inches  (99.7 x 30.5 cm)
Private Collection

> *These days, who lives like him,*
> *Rubbing shoulders with beggars all day*
> *And meditating all night?*

Although recognized as a master, Daitō (1282-1338) emulated the Zen heroes of old by secluding himself from the world for years, living as a beggar in Kyoto.  Determined to locate the reclusive priest, the emperor learned that Daitō was fond of melons and instructed an aide to use that fruit as bait to lure him out.  The aide offered the melon to a group of beggars but demanded that whoever wanted it *"Come and get it without a foot."*  When Daitō said, *"First give it without a hand"* he was found out.  Daitō later went on to establish Daitoku-ji, which eventually became the most influential Zen temple in Japan.

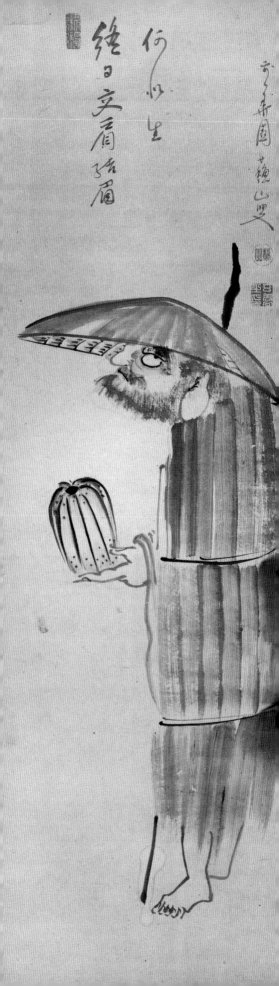

38  HAKUIN Ekaku, 1685-1769
*Tenjin*
sumi on paper
46 1/2 x 11 inches  (118.1 x 27.9 cm)
New Orleans Museum of Art: Gift of Dr. Kurt A. Gitter in memory of
his mother, Dr. Maria Gitter, 85.238

> *[Even though you cannot tell*
> *That he is wearing a robe of brocade,]*
> *You will know that it is Tenjin*
> *By the plum blossoms*
> *He carries in his sleeve.*

Genius is thought to be a manifestation of Buddha-nature, so talented men
and women are honored by Zen Buddhists regardless of their religious affil-
iation (or lack of one).  Tenjin, the deified form of the ninth century scholar
Sugawara Michizane, was one such Japanese god welcomed into the eclectic
Zen pantheon.  Legend has it that in his deified body, Tenjin went to China
to study Zen.  Thus he represents the harmonization of Shintō divine
learning and Zen realization.  Tenjin's body is constructed out of the incant-
ation, *"Hail to Tenjin, God of Great Freedom at Temman Shrine."*  Portraits such
as this were hung in the alcoves of scholars, poets, and artists for inspiration.

124

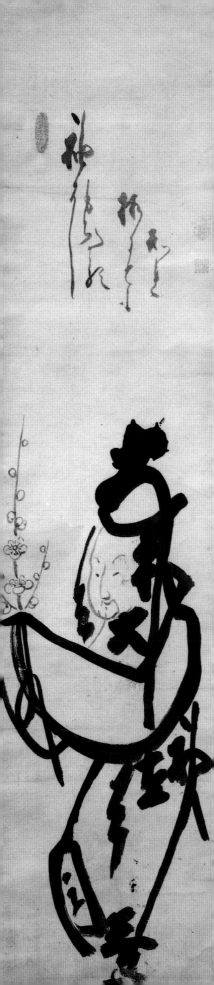

39  DAISHIN Gitō, 1656-1730
*Hitomaro*
sumi on paper
23 7/8 x 9 7/8 inches  (60.6 x 25.1 cm)
Private Collection

> *A poet among poets,*
> *A true immortal of Japanese verse.*
> *Deified as the God of poetry,*
> *His works are the pinnacle of this*
> *        nation's literature—*
> *Hitomaro, without a rival in Japan.*

Hitomaro, a seventh century figure who was deified as the god of Japanese poetry, easily found a place in the pantheon of Zen heroes.  Hitomaro's body is cleverly formed out of the characters *hito* (man) and *maru* (round, perfect). This kind of painting was displayed in the alcove on Hitomaro's memorial day.

126

百人一首君臣
三十六歌仙人
獨步和歌神聖
正一位稱禾大明神
月本ノ人丸獨り歌ノ神
非二想天ノ上ノ上十キ

紫野
光

40 SHUNSŌ Jōshu, 1750-1839
*Noh Dancer*
sumi on paper
39 1/2 x 10 7/8 inches  (100.3 x 27.6 cm)
The Gitter Collection

*If you want pleasure that will last 10,000 years*
*Watch (a Noh Master perform) Sanbansō.*

Sanbansō is a famous Noh drama.  Noh has always been closely associated
with Zen—a master actor harmonizes his body and mind with the chorus
and the audience so well that they become one.  With a minimum of
brushstrokes, Shunsō has been able to recreate all the drama and creative
tension of the play, and capture the "perfect stillness in the midst of
movement" which is the essence of Zen.

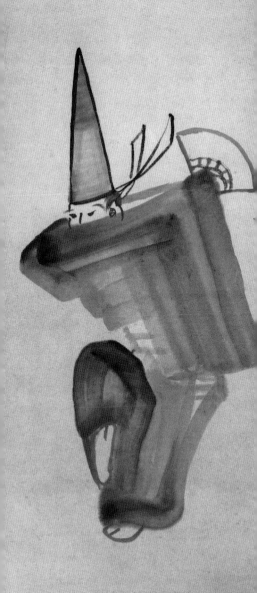

The Zen ideal is to actualize one's enlightenment in everyday life. *Satori*, "Zen awakening," is not a mystical state in which one wanders around in an empty-headed daze, but a direct perception of things just the way they are. Zen teachings are always concrete, direct, and practical (albeit occasionally presented in a puzzling fashion). As you will discover in this section, virtually any aspect of the human experience could become a subject for the Zen artist, who utilizes painting as a teaching vehicle. Zenga is thus highly instructive as well as a delight to look at.

# PRACTICE AND ENLIGHTENMENT

Zen is the religion of experience. *"In order to know if water is cold or hot,"* a Zen adage goes, *"One must taste it."* Everyone possesses the seed of awakening, but it will not bear fruit unless it is cultivated. Training in Zen must not be thought of as asceticism or a self-imposed penance; rather it is a forging of the body and mind, a wearing away of the rough edges. The purpose of Zen training is to bring the inner realities into focus and to foster mindfulness and compassion.

41  HAKUIN Ekaku, 1685-1769
*Monk on Pilgrimage*
sumi on paper
15 1/4 x 21 7/8 inches  (38.7 x 55.5 cm)
The Gitter Collection

*Fashion a solid bridge in your heart*
*and others, too, will be able to cross over.*

The first step in Zen training is pilgrimage—an outer pilgrimage to confront the best teachers and an inner pilgrimage to the deepest recesses of one's mind. Enlightenment in Buddhism is often compared to making a journey from this shore (*samsara*=illusion) to the other shore (*nirvana*=enlightenment). Like most Zen masters, Hakuin spent many years as an *unsui*, a pilgrim monk, drifting with the clouds and flowing with the water in search of the Way, and the figure in this painting is likely a self-portrait. The bridge is very narrow, its planks rickety, and the monk assailed by strong winds. The pilgrim is alone, for despite the help and encouragement received from others, a Zen practitioner must tread the path and find the truth on his or her own. One successful journey can inspire many others to attempt the same trip.

132

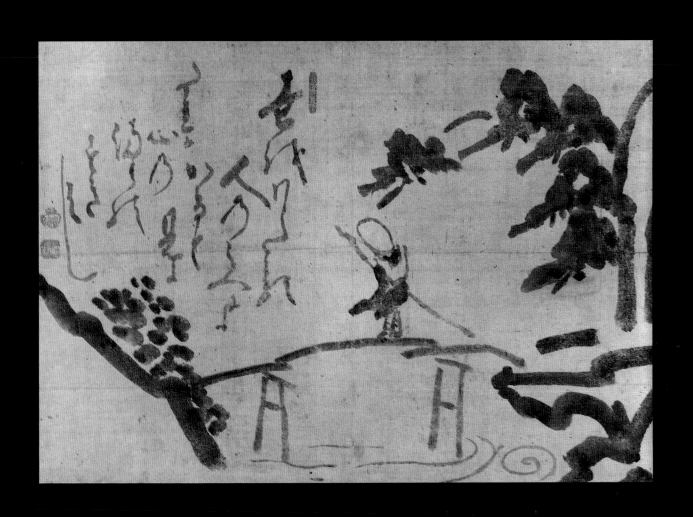

42  Nakahara NANTEMBŌ, 1839-1925
*Zen Staff*, 1923
sumi on paper
53 3/8 x 12 7/8 inches  (135.6 x 32.7 cm)
Private Collection

> *Nantembō's fearsome staff ushers in a spirited*
> *New Year;*
> *What kind of things will he beat out this spring,*
> *here at Keisei-ji?*
> original poem by General Nogi

The second stage of Zen training is study under a master.  Often the student is presented with a *kōan*, a Zen riddle, to ponder over day and night.  When a student approached Nantembō, who was always armed with a heavy stick, he or she better have a good answer ready—Nantembō's trademark was *"Whether you speak or not, thirty blows from my staff!"*  That is, clever phrases, glib philosophizing, or pretentious silence will earn one a sharp crack on the head.  Zen masters must be very severe with their students, for Zen training is indeed a matter of life or death.

134

43 KŌGAN Gengei, 1747-1821
*Procession of Monks*
sumi on paper
46 1/2 x 14 1/8 inches (118.1 x 35.9 cm)
New Orleans Museum of Art: Museum Purchase, 90. 42

*One voice, two voices—then like*
*a clatter of shivering geese!*

While much Zen training is a solitary pursuit, community life is also important. Following the example of Buddha, Zen monks still make mendicant rounds, begging for food and money. Kōgan has captured the mood of such a procession perfectly—some serious monks have their eyes straight ahead as the rules prescribe, but others are gawking about and one confronts a puppy, reminiscent of the famous *kōan, "Does this dog possess the Buddha nature?"* The inscription, too, pokes gentle fun at the chanting of the monks. In unison when they start out, gradually the distracted monks lose the beat and start making quite a racket, sounding more like quacking geese than Buddhist priests.

136

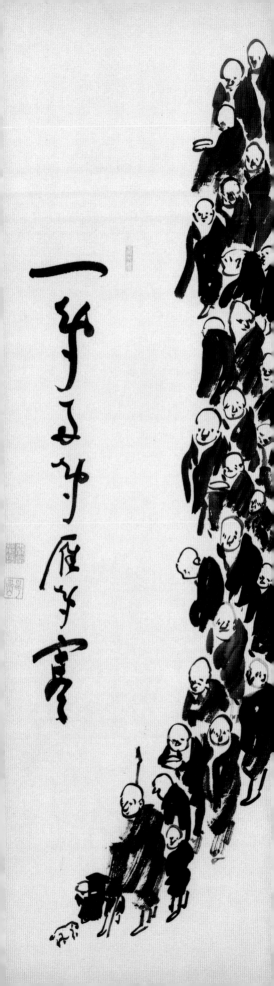

44  TŌREI Enji, 1721-1792
*Zen Circle of Enlightenment*
sumi on paper
12 3/8 x 21 3/4 inches  (31.5 x 55.2 cm)
The Gitter Collection

*In heaven and on earth, I alone am the
Honored One!*

Suddenly all inner doubts are resolved and everything is seen just as it really
is.  A Zen *ensō* (circle) reflects that transforming experience—perfectly empty
yet completely full, infinite, shining brightly like the moon-mind of
enlightenment.  The inscription repeats Buddha's dramatic declaration at
birth—each person is a miniature universe, containing all things within his
or her body, and enlightenment consists, in part, of realizing that fact.  Tōrei,
one of Hakuin's chief disciples, was the greatest of *ensō* painters.

138

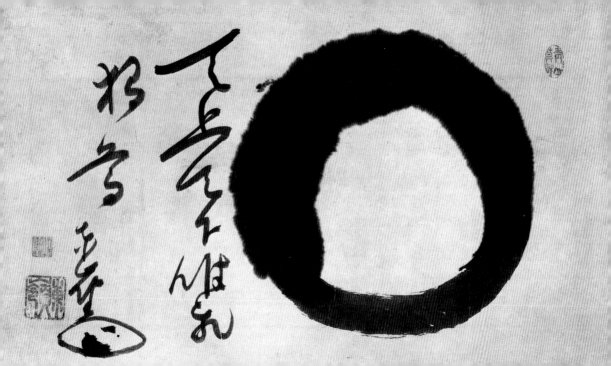

45  TSU'Ō Sōtetsu, 1801-1854
*Enlightenment Certificate*
sumi on paper
39 1/4 x 12 inches  (99.1 x 30.5 cm)
New Orleans Museum of Art: Museum Purchase, 89.53

> *Use this fly whisk and staff to sweep away*
> *the world's ills and confusion.*

When a master was satisfied with a disciple's attainment, he or she would be presented with an *inka* (enlightenment/teaching certificate).  Frequently the *inka* was in the form we see here—the fly whisk symbolizes teaching authority and the staff, leadership.  *"Seeing into one's nature"* is not by any means the end of one's Zen training; on the contrary, it marks the beginning of  a career dedicated to the spiritual welfare of others.  Enlightened activity in the midst of the world's turmoil, not bump-on-a-log meditation, is the real aim of Zen.  This certificate was presented to a lay disciple—Zen has never been the exclusive province of monks.

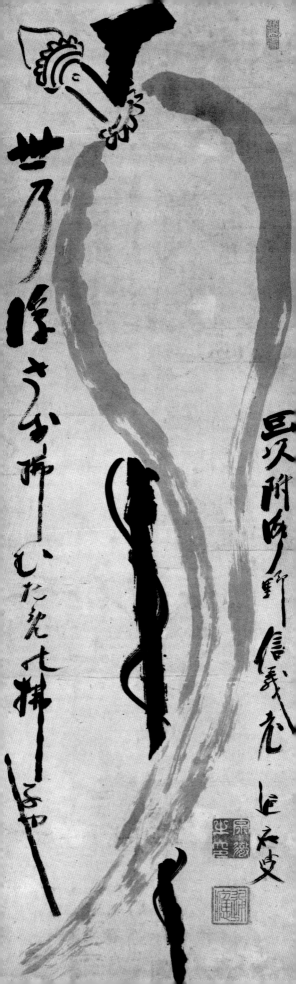

## VISUAL SERMONS

One of the meanings of Zen is "all-inclusive," and it draws inspiration from other schools of Buddhism, Confucianism, Shintōism, Taoism, folk religion, Christianity (in modern times) and scenes from everyday life—indeed, any subject could be used to convey Zen truths with brush and ink. One of the seals which Hakuin stamped on his brushwork read:

*Paintings that help sentient beings attain liberation.*

46  HAKUIN Ekaku, 1685-1769
*Blind Men on a Log Bridge*
sumi on paper
11 1/16 x 33 inches  (28.0 x 83.8 cm)
The Gitter Collection

*In both spiritual training and dealing with the*
*    world,*
*Keep in mind a blind man crossing a dangerous*
*    bridge.*

Hakuin could have sermonized about such a theme; but that would have been much less effective than this Zenga, a religious and artistic masterpiece, which makes immediate and lasting impact. There was actually a bridge and a deep gorge like this near Hakuin's temple and he incorporated it into his art as a metaphor for the precariousness of life. A blind man, of course, is especially careful when groping his way across a dangerous bridge. Be similarly alert, Hakuin tells us, and you can make it safely across. Despite the seriousness of the message, there is nothing gloomy or depressing about this painting; on the contrary, it has a calming and purifying effect on the viewer.

142

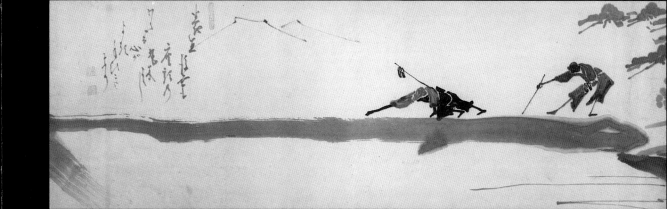

47   HAKUIN Ekaku, 1685-1769
*Bonseki*
sumi on paper
11 1/4 x 20 5/8 inches  (28.6 x 52.4 cm)
The Gitter Collection

Ostensibly a painting of a *bonseki*, a miniature landscape in a tray, this is really a clever satire about misbehaving monks.  On the surface the inscription says:

> *Mr. Bon,*
> *Are you going to worship*
> *at Ishiyama Temple?*

"Bon," however is a homonym for "monk;" near Ishiyama Temple there was a famous red-light district that was really the main attraction.  Thus, the inscription also means:

> *Mr. Monk,*
> *Are you going to Ishiyama Temple*
> *To play with the ladies?*

Upon closer examination of the painting, we notice that "Mr. Monk" is fully armed and prepared for such an illicit excursion.  Hakuin refrains from a fire-and-brimstone condemnation of the monks, relying instead on satirical humor to make his point.  Interestingly, it appears that such paintings also served as sex talismans for Hakuin's lay parishoners.

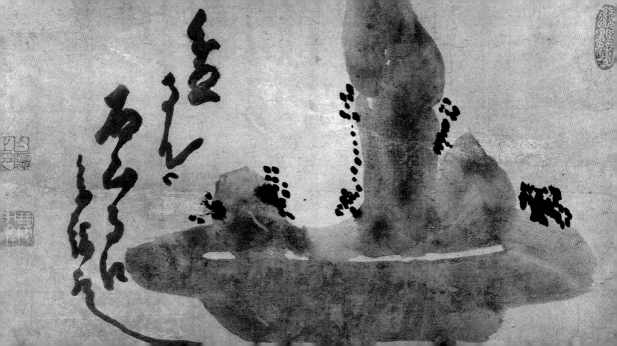

48  HAKUIN Ekaku, 1685-1769
*Treasure Boat*
sumi on paper
13 1/2 x 22 inches (34.3 x 55.9 cm)
New Orleans Museum of Art: Museum Purchase, 88.211

*Those who are loyal to their lord and filial*
*to their elders will be presented with this*
*raincoat, hat, mallet and bag.*

The treasure boat in popular folklore is piloted by Fukurokujū, the God of Longevity (whose face resembles that of the artist). The boat itself is deftly formed by the character *kotobuki* (long life) and contains the four symbols of good fortune: the lucky raincoat, a straw hat (representing the gift of invisibility from thieves and tax collectors), a magic mallet (the Japanese version of Aladdin's lamp), and a treasure bag. The best way to steer through the rapids of life is to board this ship as soon as it is launched—one who is sincere in his or her dealings with fellow human beings will be blessed with wealth and good fortune. The composition of the painting is light, bright and buoyant (notice how high the boat rides on the waves) while the message is deep and universal.

146

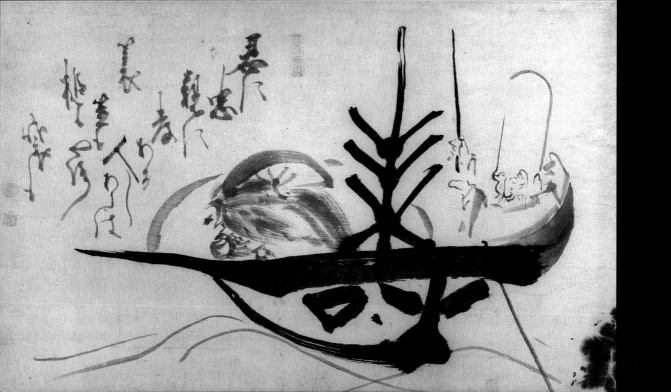

49 SENGAI Gibon, 1750-1838
*Three Gods of Good Fortune*
sumi on paper
36 5/8 x 10 3/4 inches  (93 x 27.3 cm)
New Orleans Museum of Art Collection:
Gift of Dr. and Mrs. Kurt A. Gitter, 75.407

*Blend the Three Fortunes*
*Into one big lump*
*And brew the Elixir of Happiness.*

A painting of Sengai's was said to have touched a greedy merchant so deeply that he immediately mended his evil ways; others have said that when they look at Sengai's joyous art they feel as if a heavy burden is lifted from their shoulders.  The Three Gods of Good Fortune are, *top*, Daikoku (good harvests), *middle*, Ebisu (good fishing), and, *bottom*, Fukurokujū (long life).  The inscription means:  *"Illumine the mind, be content with what you have, do not fret about this and that, and you will possess good fortune in abundance."*

148

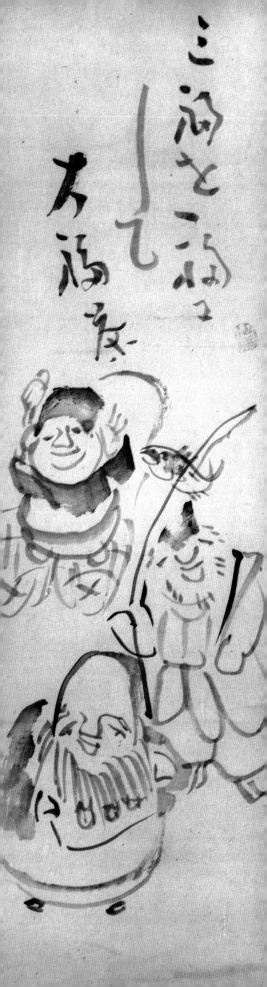

## ZEN AND NATURE

An old Zen saying goes,

> *Before I studied Zen, mountains were mountains and rivers were rivers; while I was studying Zen, mountains were not mountains and rivers were not rivers; after I understood Zen, mountains were again mountains, and rivers were again rivers.*

That is, in a state of ignorance, mountains are thought to be nothing more than a big pile of rocks and rivers, just a gush of water; during Zen training, one tends to see everything as a projection of the deluded mind; upon realization, however, mountains and rivers are seen for what they are—manifestations of Buddha-nature.

50  SUIŌ Genrō, 1716-1789
*Zen Landscape*
sumi on paper
44 1/4 x 11 1/4 inches  (112.4 x 28.6 cm)
New Orleans Museum of Art: Anonymous Gift, 78.149

> *I recall a painting of a famous view of China,*
> *Peak after peak appears in my mind.*

Although apparently a winter scene, this vibrant landscape seems to have come into existence right out of the paper rather than at the hand of a painter. Zenga, as we can see here, is painting of the mind. The inscription, too, alludes to the "mountains of one's mind." While Tōrei, Hakuin's other chief disciple, was known for his serious character and strict observance of monastic precepts, Suiō was just the opposite; a free spirit who detested the confines of temple life and loved wine and women. Hakuin cherished them both.

圖畫若年花園在
清公七十二峰青

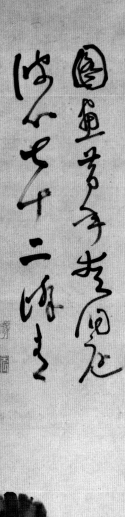

51 SENGAI Gibon, 1750-1838
*Zen Landscape*
sumi on silk
37 1/2 x 17 3/8 inches (95.2 x 44.1 cm)
The Gitter Collection

> *Morning and evening,*
> *From Hakozaki Beach*
> *You can see,*
> *In the middle of the sea,*
> *Shikashima Island.*

A Zen text states: *"Emptiness is form, form is emptiness."* Even though this painting consists of mostly empty space, a complete vista appears. The painting projects a warm inner glow and has a refreshing undercurrent of peace and stability. The scene itself is of lovely Hakozaki Beach in Kyūshū, one of Sengai's favorite places. What, the artist asks, could be more wonderful?

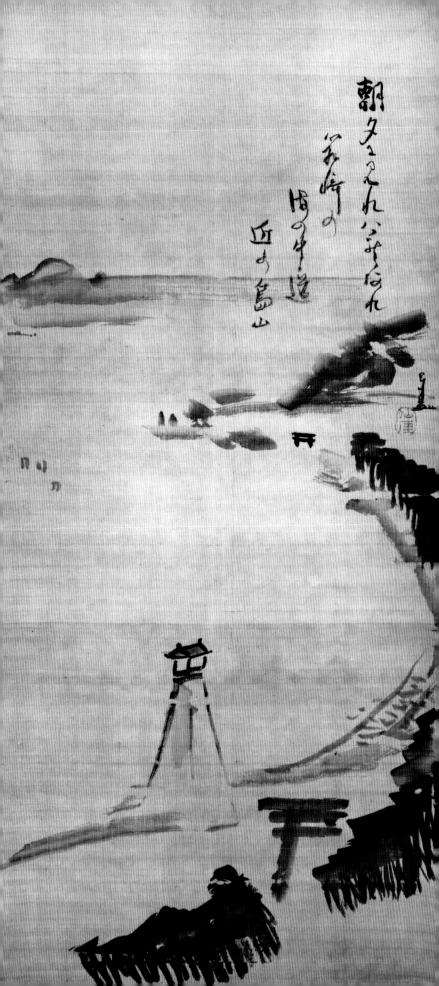

52  REIGEN Etō.  Japan, 1721-1785
*Shrine of Tenjin*
sumi on paper
39 1/4 x 10 7/8 inches  (99.6 x 27.6 cm)
The Gitter Collection

> *Pines and plum blossoms*
> *Within the shrine —*
> *No need to ask which one.*

Temman-gū, the shrine of Tenjin, is Kyoto's best known *jinja*.  Again, the Zen artist reduces the scene to its primary elements—the majestic Shintō gate (only half shown), a sprig of plum blossoms, and a small cluster of pines—and does not even give the name of the place.  Yet despite the extreme reduction there is no sense that something is missing and the scene brings to mind the Zen proverb, *"One branch blooms and spring comes to ten thousand lands."*

154

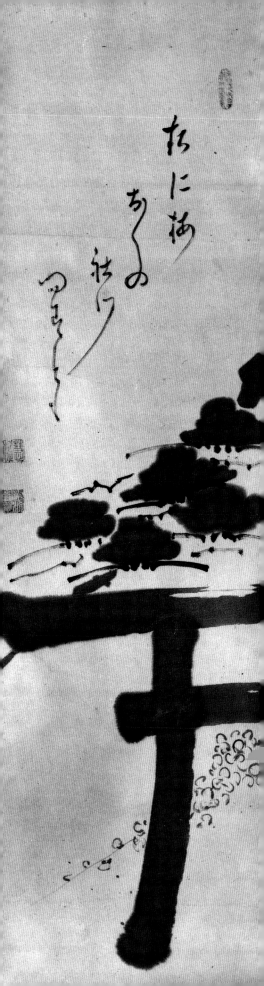

## MT. FUJI

Zen paintings of Mt. Fuji are totally different from those gorgeously painted in oils by professional artists; a Zen Fuji is an imposing reality, anchored to the earth yet extending above the clouds—a perfect symbol of Zen meditation. According to the Zen interpretation, the name "Fuji" is written with the characters meaning "not two," representing the non-duality of spirit and matter.

53  CHŪHŌ Sōu, 1759-1838
*Mt. Fuji*
12 x 21 3/8 inches  (30.5 x 54.3 cm)
sumi on paper
The Gitter Collection

> *Since it is not two or three,*
> *It is the best there is!*

Here, Fuji is an unsurpassed symbol of the unity of spirit and matter— *"transcend all duplicity and reign supreme!"* Chūhō, who once served as head abbot of Daitoku-ji, was a great admirer of Jiun (cat. no. 64), and we can see the influence of that master in Chūhō's brushwork.

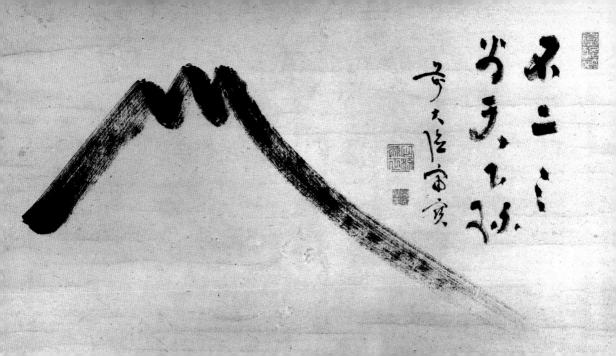

54  REIGEN Etō, 1721-1785
*Mt. Fuji*
sumi on paper
13 1/2 x 22 1/4 inches  (34.3 x 56.5 cm)
Private Collection

*Number one, Fuji;*
*Number two, a hawk;*
*Number three, eggplants.*

This simple painting has many complex allusions.  In Japan, the first dream of the year carries great importance since it is believed to portend what is in store for the ensuing twelve months.  The best dream is of Mt. Fuji.  Fuji also symbolizes great ambition that reaches towards the clouds.  Just as a hawk seizes the opportunity to capture its prey, we should act boldly in order to attain good fortune.  A field of eggplants represents realization of all one's dreams.  In short, Zen—symbolized by the majestic form of Mt. Fuji—is a field of good fortune for those who grasp its essence.

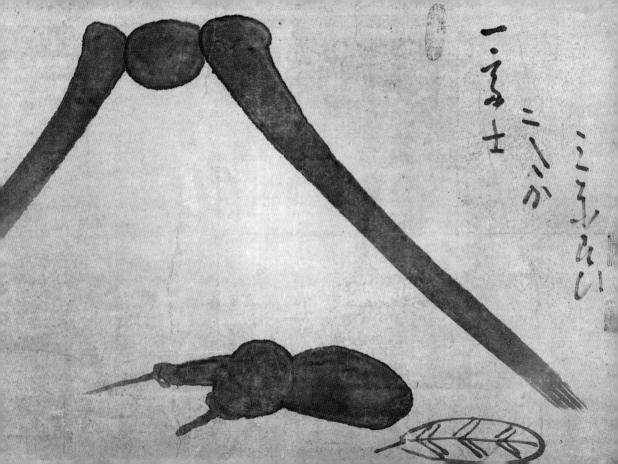

55  SHUNSŌ Jōshu, 1750-1839
*Mt. Fuji*
sumi on silk
6 3/8 x 15 3/8 inches  (16.2 x 39.1 cm)
Private Collection

This charming little landscape has a bit more detail than most Zen Fuji
paintings, emphasizing the solid, harmonious presence of the mountain.
This painting was likely brushed for one of Shunsō's parishioners who
would display it in the family alcove during the New Year.

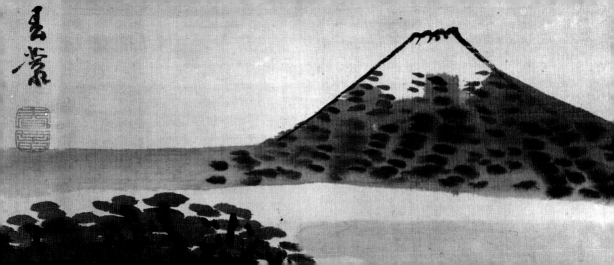

56 Ōtagaki RENGETSU, 1791-1875
*Drying Persimmons*, 1868
sumi on paper
6 3/4 x 6 inches  (17.2 x 15.2 cm)
New Orleans Museum of Art: Anonymous Gift, 77.83

*The little persimmons drying outside*
*Under the eaves*
*of my hermitage—*
*Are they freezing tonight*
*In the winter storm?*

Although the nun Rengetsu, one of Japan's finest female artists, did not really paint in the Zen style, she practiced Zen meditation and her work is imbued with the Zen spirit—simple, direct and centered.

162

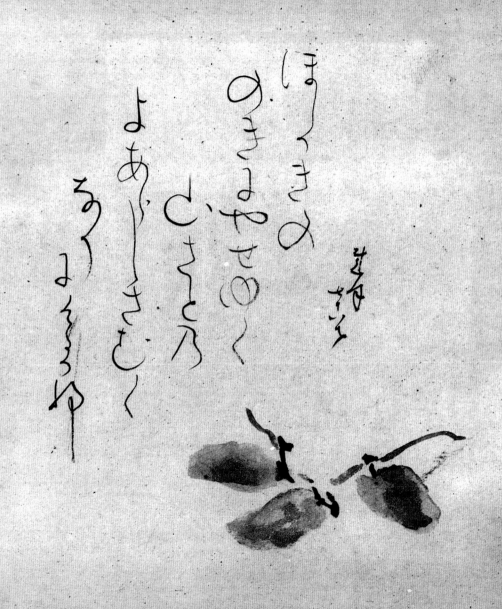

57 HAKUIN Ekaku, 1685-1769
*Monkey*
sumi on paper
27 3/8 x 6 3/4 inches  (69.5 x 17.2 cm)
The Gitter Collection

*Yoshida is no better than a fly's head!*

Hakuin frequently caricatured dilettante monks and pompous lords in his Zenga. Here he lampoons the literatus Yoshida Kenkō as a monkey foolishly trying to grasp the moon's reflection on the water. Real Zen masters do not live in refined retirement, leisurely dabbling in art and religion. Yet, there is nothing mean or petty about Hakuin's scorn; in fact, the monkey is brushed with a great deal of affection. After all, even though the monkey may be confused, if it stops searching, all will be lost. Sooner or later, we sense that Hakuin's monkey will grasp the truth, not illusions.

164

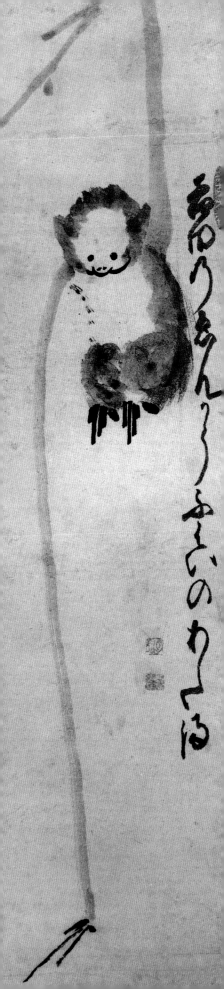

When a Chinese emperor asked a renowned calligrapher how to hold the brush he was told : *"If your mind is correct then the brush will be correct."* This holds true for any spiritual discipline. If one's mind is crooked or warped, so will be one's technique. When a calligrapher is one with the brush, ink, paper and subject, the strokes come alive; if the calligrapher is distracted or full of delusion, the lines will be dead no matter how well they are constructed. That is the spirit of Zen calligraphy.

58  HAKUIN Ekaku, 1685-1769
*Two Line Calligraphy*
sumi on paper
39 1/2 x 11 inches  (100.3 x 27.9 cm)
Private Collection

*Through piercing discipline*
*the ancients grew illustrious.*

Jimyō (Tzu-ming) was a Chinese master who pierced his thigh with a gimlet when he became drowsy during Zen meditation.  When asked the reason, Jimyō replied, *"Through piercing discipline the ancients grew illustrious.  To achieve nothing in one's lifetime and die without any accomplishments is a terrible waste.  That is why I pierce my thigh."*  In modern parlance, "No pain, no gain."

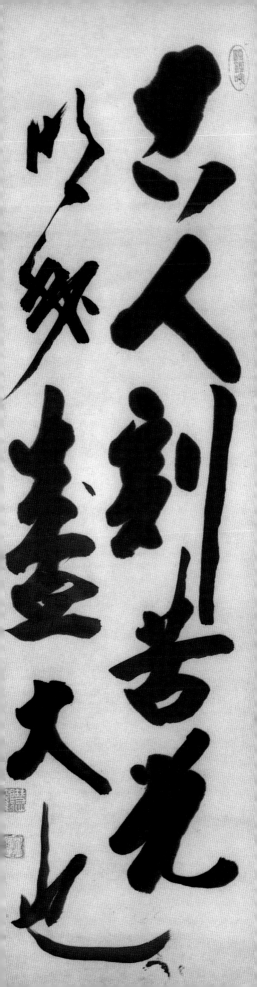

以人刻苦先

以毅功盡大也

59  HAKUIN Ekaku, 1685-1769
*Three Shintō Deities*
sumi on paper
38 x 11 3/8 inches  (96.5 x 28.9 cm)
Private Collection

*(left)*
*Kasuga Daimyōjin*
*(center)*
*Amaterasu kō Daijingū*
*(right)*
*Hachiman Daibosatsu*

In esoteric Buddhism, the Shintō deities are considered local manifestations of Buddhas and Patriarchs.  From the Zen standpoint, whatever brings out the best in human beings is worthy of respect, and Zen masters frequently brushed art for the followers of other sects and religions.

天照皇大神

大日孁貴

天照皇大神宮

大菩薩

春日

60  HAKUIN Ekaku, 1685-1769
*Death Kōan*
sumi on paper
13 x 19 7/8 inches  (33.0 x 50.5 cm)
The Gitter Collection

> *Death—the great activator of the patriarchs of old*
> *and the basis of human life.*

Calligraphic *kōans* with the "Death" theme were one of Hakuin's trademarks.
Two other inscriptions he used on such pieces were:  *"Young people!  If you
do not want to die, then die now; if you die once, you won't die again"* and
*"Anyone who sees through death becomes an ageless, deathless immortal."*

死

不祖大悟
人々ともの脈

61 HAKUIN Ekaku, 1685-1769
*Virtue*
sumi on paper
46 3/16 x 21 3/4 inches  (117.3 x 55.2 cm)
The Gitter Collection

*If you pile up money for your descendants*
*they will be sure to waste it; if you collect books*
*for them they probably will not read a word.  It*
*is better to pile up virtue unobtrusively—*
*such a legacy will last a long, long time.*

Monumental both in scale and depth, this "one-word barrier"—a giant character set off for emphasis—perfectly expresses the gravity and overwhelming force of the Zen experience.  The inscription contains wisdom that is both practical and inspiring as well as being universally valid.

62  HAKUIN Ekaku, 1685-1769
*Always Remember Kannon*
sumi on paper
52 1/4 x 11 inches  (132.7 x 27.9 cm)
The Gitter Collection

*Always Remember (the compassion of) Kannon Bosatsu*

Another one of Hakuin's calligraphic trademarks— *"Always keep in mind the goodness and compassion of the Goddess Kannon* (Kanzeon) *and act accordingly."* Brushed very near the end of his life, the massive brushstroke for "Always Remember" is extraordinarily lucid, clear and powerful.

63 TŌREI Enji, 1721-1792
*Calligraphic Talisman*
sumi on paper
50 3/4 x 10 7/8 inches  (128.9 x 27.6 cm)
The Gitter Collection

*Kompira Daigongen*

Kompira is the patron deity of sailors and others who make their livelihood from the sea and *daigongen* means "avatar" i.e., a Buddhist principle manifesting itself in Shintō form.  This kind of calligraphy was brushed by virtuous priests to serve as a talisman, effective, Hakuin wrote, *"For warding off fire and theft, preventing natural disasters, fostering happiness and long life, and securing peace for one's home and the entire world."*  The brushstrokes in this piece, one of Tōrei's finest, are rich and vibrant.

178

金風颯颯大權現

64 JIUN Onkō, 1718-1804
*Two Line Calligraphy*
sumi on paper
43 7/16 x 19 11/16 inches (110.3 x 50.0 cm)
The Gitter Collection

*Why is it necessary for a hermit*
*to live in the mountains?*

A real hermit can maintain his or her inner tranquility anywhere—in a cave or on a street corner. Jiun used a reed rather than a hair brush when composing his distinctive calligraphy.

大徹大悟無思量

羽童父

65  a & b Ōtagaki RENGETSU, 1791-1875
*Tanzaku Poems*, 1870
sumi on paper
14 1/2 x 2 3/8 inches each  (36.8 x 6.0 cm)
Private Collection

> *(left)*
> *Mist*
> *From morning,*
> *Perfectly tranquil,*
> *Far removed from*
> *The world's turmoil—*
> *(I am concealed by) spring mist.*

> *(right)*
> *Moonlit Evening*
> *The mountain dwellers*
> *Will be busy tomorrow (harvesting),*
> *Using these sharp sickles*
> *that shine brightly*
> *In this evening's moonlight.*

Rengetsu's mature brushwork displays exceptional vitality, tensile strength, and profound insight, attributable to her noble character, breadth of experience, and spiritual perspective.

182

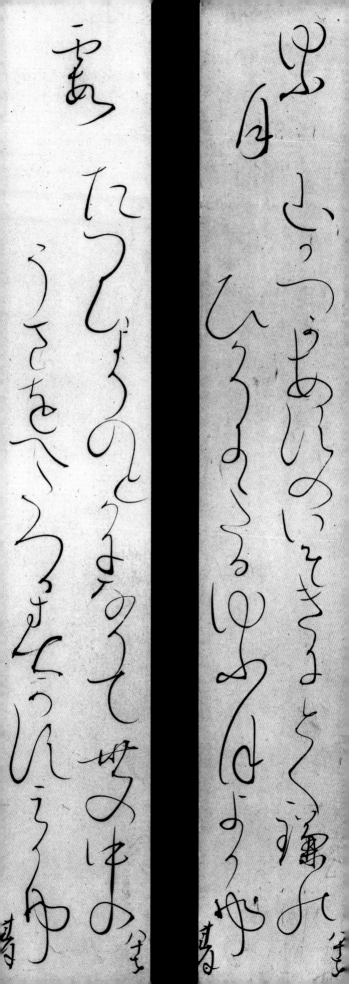

66  Yamaoka TESSHŪ, 1836-1888
*Dragon*
sumi on paper
17 1/2 x 23 3/4 inches  (44.5 x 60.3 cm)
The Gitter Collection

*Dragon—It feasts on sunlight and the four seas!*

Tesshū's motto was *"Unified in body and spirit, there is nothing that cannot be accomplished."*  In this inspiring work, calligraphy and painting have been combined; the character for dragon has also assumed the form of that fantastic creature.  The layman Tesshū—master of Zen, the sword, and the brush—was the most prolific of the Zen artists.  He created more than a million pieces, mostly to raise money for charity and other worthy causes, in a ten-year span, averaging  five hundred pieces a day.

184

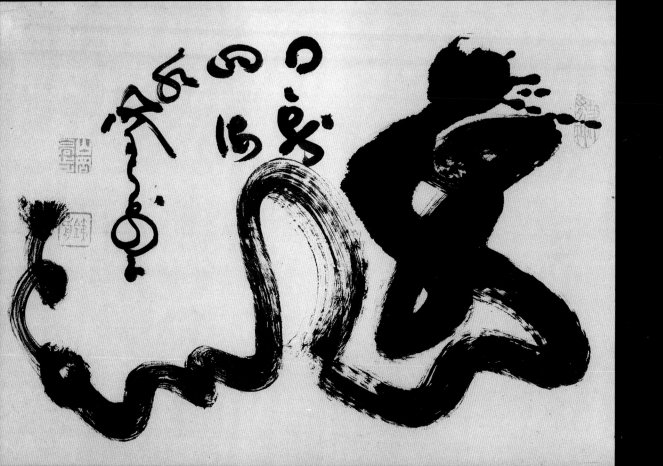

# CALLIGRAPHIC SCREENS

On occasion, Zen calligraphy is mounted on scrolls for display in temples or large halls. The effect of encountering entire panels covered with large, dynamically brushed characters can be stunning.

67 a & b  Yamaoka TESSHŪ, 1836-1888
*Pair of Six-Panel Screens*
sumi on paper
53 x 19 15/16 inches each panel  (134.6 x 50.6 cm)
The Gitter Collection

> *The colorful (flowers) are fragrant*
> *But they must fall;*
> *Who in this world of ours*
> *Can live forever?*
> *Today, cross over the deep mountains*
> *Of life's illusions,*
> *And there will be no more shallow dreaming*
> *No more intoxication.*

This illustrates the *i-ro-ha*, the Japanese syllabary. The Buddhist saint Kōbō Daishi, popularly credited with the invention of the cursive script, arranged the fifty-one syllables into a Buddhist poem.

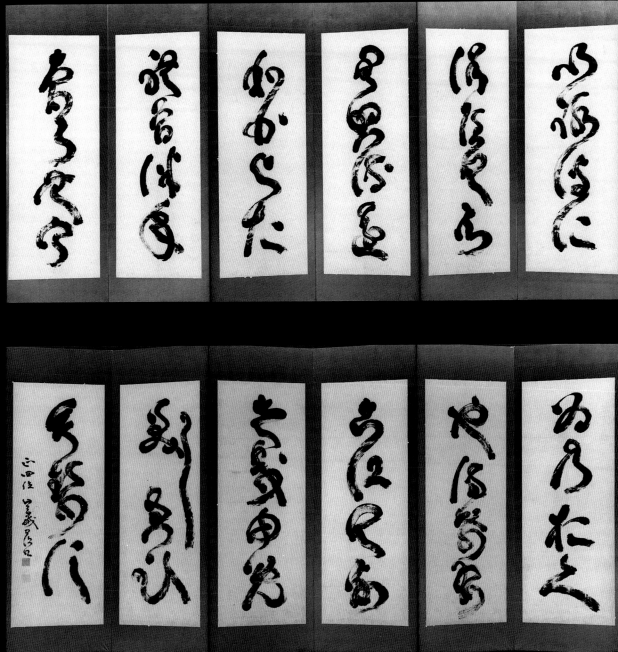

68 a & b  Nakahara NANTEMBŌ, 1839-1925
*Pair of Two-Panel Screens*, 1923
sumi on silk
55 1/16 x 22 13/16 inches each panel  (139.9 x 58.0 cm)
The Gitter Collection

*(top)*
*Practice Righteousness — Loyalty — Filial Piety*
*(bottom)*
*Practice Filial Piety — Practice Loyalty*

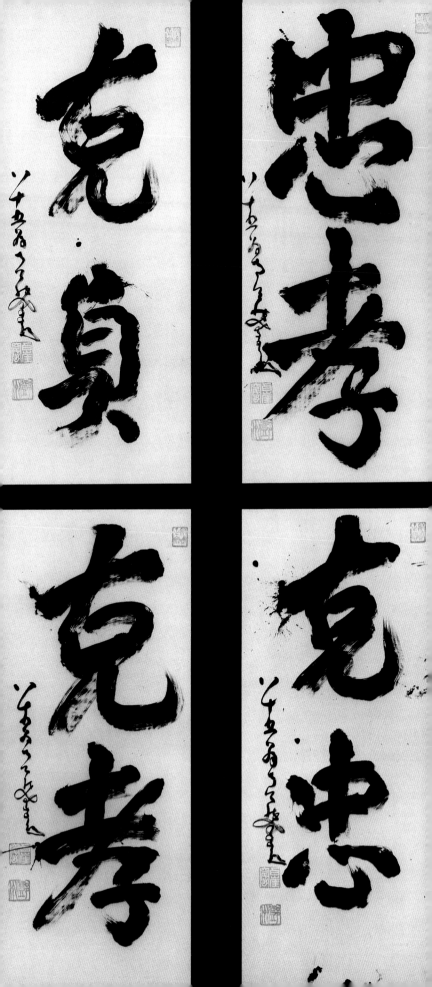

Zen Art is meant to be contemplated. One has to experience Zenga, not just look at it. Explanations can be helpful but ultimately it is up to the viewer to understand Zenga in his or her own way.

69  Nakahara NANTEMBŌ, 1839-1925
*Zen Circle*, 1923
sumi  on silk
13 1/4 x 14 1/8 inches  (33.7 x 35.9 cm)
Private Collection

*Within the spinning*
*Circle of life*
*We are born;*
*The human heart, too,*
*Should be kept round and complete.*

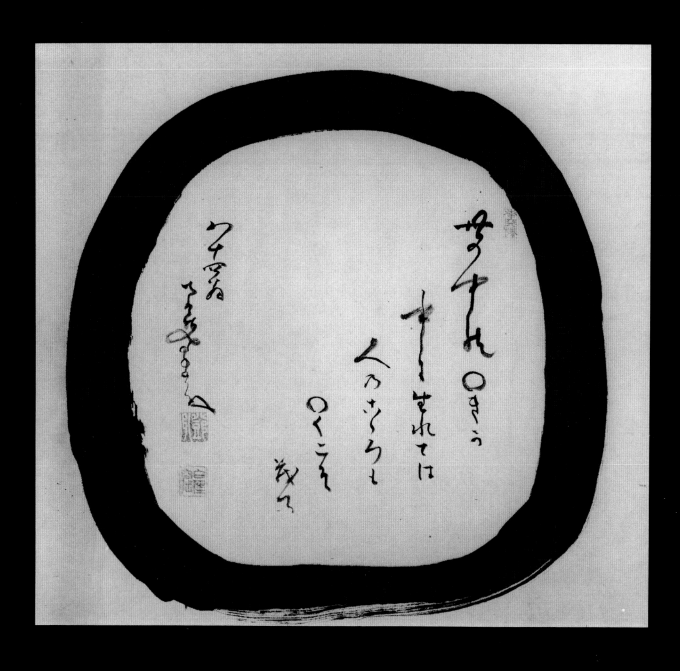

70 REIGEN Etō, 1721-1785
*Kōan*
sumi on paper
52 3/8 x 22 inches  (133.0 x 55.9 cm)
Private Collection

*All things return to the ONE;*
*To where does the ONE return?*

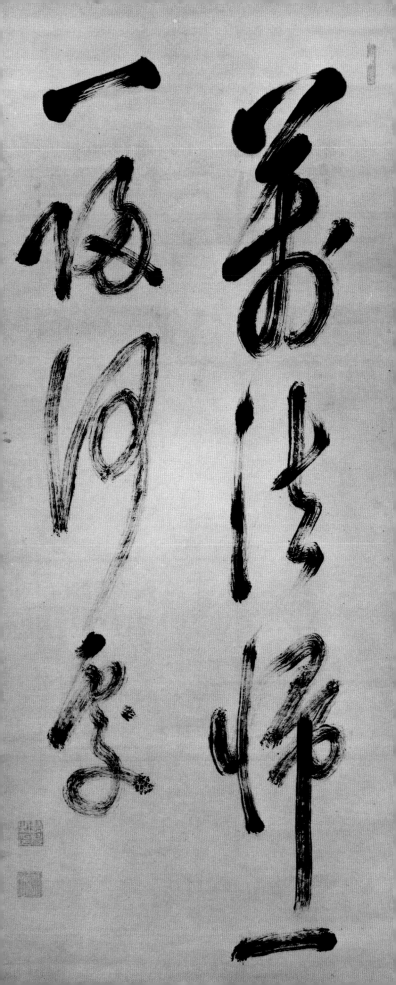

Addiss, S. *The Art of Zen*. New York: Henry N. Abrams, 1989.

_____. Ōbaku. *Zen Painting and Calligraphy*. Lawrence, Kansas: Spencer Museum of Art, 1978.

_____. *Zenga and Nanga*. New Orleans: New Orleans Museum of Art, 1976.

Addiss, S. ed. *A Myriad of Autumn Leaves*. New Orleans: New Orleans Museum of Art, 1983.

Awakawa, Y. *Zen Painting*. Tokyo: Kodansha International, 1970.

Barnet, S. and Burto, W. *Zen Ink Painting*. Tokyo: Kodansha International, 1982.

Brasch, K. *Hakuin und die Zen Malerei*. Tokyo: Japanische-Deutsche Gesellschaft, 1957.

_____. *Zenga*. Tokyo: Japanische-Deutsche Gesellschaft, 1961.

Brinker, H. *Zen in the Art of Painting*. London: Arcana, 1987.

Fontein, J. and Hickman, M. *Zen Painting and Calligraphy*. Boston: Museum of Fine Arts, 1970.

Hisamatsu, S. *Zen and the Fine Arts*. Tokyo: Kodansha International, 1971.

McFarland, H.N. *Daruma: The Founder of Zen in Japanese Art and Popular Culture*. Tokyo: Kodansha International, 1987.

Ōmori, S. and Terayama, K. translated by J. Stevens. *Zen in the Art of Calligraphy*. London: Routledge and Kegan Paul, 1983.

Stevens, J. *Sacred Calligraphy of the East* (Revised Edition). Boston: Shambhala Publications, 1988.

_____. *The Sword of No-Sword: The Life of the Master Warrior Tesshū*. Boston: Shambhala Publications, 1989.

_____. "The Appreciation of Zen Art," *Arts of Asia* 16, No. 5 (1986).

_____. "Brushstrokes of Enlightenment," *Transactions of the Asiatic Society of Japan*, fourth series, No. 1 (1986).

Suzuki, D.T. *Sengai, the Zen Master*. Greenwich, Conn.: New York Graphic Society, 1971.

_____. *Zen and Japanese Culture*. Princeton: Princeton University Press, 1959.

Tanahashi, K. *Penetrating Laughter: The Art of Hakuin*. Woodstock, New York: Overlook Press, 1984.